Dear Mr Andrews

a memoir

Lotte Latham

Guts Publishing

Praise for Dear Mr Andrews

"Some of our best-loved books are never what they purport to be. *Cooking in a Bedsitter* (1961) is more than a collection of recipes, just as *Bridget Jones's Diary* (1996) is less than a quest for self-improvement. I would say something similar of *Dear Mr Andrews* (2023), which is neither an epistolary nor a confessional but a Millennial's epic journey through the precarious landscape of the 21st century's geo-digital economy.

Written in swift, clear-eyed prose, Latham's wry, insightful narrator is an erotic ethnographer who has managed to convince this late-born Boomer that if you can't be honest, at least be true. An important distinction, one that harkens back to de Sade and returns to us generationally through writers like Colette, Anaïs Nin, Angela Carter and Tamara Faith Berger. I would respectfully add Lotte Latham to that list. Dear Mr Andrews is a remarkable debut." — Michael Turner, author of *The Pornographer's Poem*

"A titillating, absurdist and dangerous screed on sex work, which, in her own words, is what that keeps Latham sane. I will add: stone cold lucid. Latham divulges the truth of female recklessness with her real treat of a mind. Dear Mr. Andrews is sweet and bitter and perfectly baked, cutting the lines between sugar babying, escorting and civilian work in a turbulent loop of righteousness." — Tamara Faith Berger, author of *Maidenhead*, The Believer Book Award 2012

"A brutally honest candy trip dedicated to Lotte's muse, the Daddy that got away. Each chapter unwraps relatable confessions about the nuanced motivations behind dating, love,

work, and sex and where they stick together under capitalism and misogyny. Lotte's voice is sweet, perverse and deeply self-aware as she navigates the economics of defiance and goes at her own cavities with sharp picks." — Sadie Lune, co-author of *As You Wish, My Lady*

"Dear Mr Andrews has everything I want from a memoir. Sugar babies, daddies, johns… A natural successor to Lynne Tillman and Kathy Acker. Latham's writing is as sexy as it is stylish." — Barry Pierce, writer and critic

"She'll show you 'how much loneliness there is in the world,' among so many life lessons. This book is Lotte's clarion call for compassion. Go ahead, readers, take a deep peek. What's not to love about Dear Mr Andrews? Absolutely fucking nothing. Guts Publishing hits another one out of the cricket field. This book is a victory for all women." — Karla Linn Merrifield, author of *My Body the Guitar*, 2021 National Book Award Nominee

"Filthy and fascinating – a frank, complex, thoughtful memoir, told in a (mostly) one-sided epistolary format. *Dear Mr Andrews* offers a unique window into the world of sugar dating. It's a visceral and viscerally enjoyable read – honest, insightful, vital, dirty and sublime." — Kristan X, author of *Lascivity*

"In an absolute act of submission this playful, hilarious, candid book dares to lay things bare for our entertainment. Highly recommended." — Susanna Kleeman, author of *Twice*

"Promiscuity is better than nothing."

Tennessee Williams

Foreword

Sugaring is a structured form of dating where one person (usually a young woman or gay man) trades intimacy in return for material goods (usually from an older man). Examples might include an allowance, or that new camera you desperately need, or a cash bail out, or a holiday, or a job.

There are websites for couples to meet under this premise. They talk about *arrangements* and make the concept of dating sound like a business deal. Although what they're touting is soft solicitation, they work via a legal loophole that allows them to get around local prostitution laws.

Admittedly, I got into escorting via sugar dating. It seemed less scary to me than escorting as it provides a veil of plausible deniability. Say someone outed you as a hooker? That shit tears families apart! But if you get caught with some guy paying your rent each month, it can be passed off as being savvy.

My experiences in sugar dating were mostly ppm *(pay per meet)* which is as close to prostitution as the format gets. For me, that was because of a discomfort in offering sexual favours indefinitely. One doesn't wish to be held over a barrel.

The biggest sugar platform says:

"Sugar Babies aren't paid. They're given gifts. If you want to be paid for your time, get a job."

What are these gifts for though? There's something so infantilising about it. Seeing men as 'providers' and women as

pretty objects hanging on their arm is old school at best. What I find most-alarming about sugar culture **is** that it's **so** acceptable and becoming an increasingly viable route for young women/gay men to get themselves off the ground. Manipulation, false promises, and ghosting are commonplace. It's open to abuse at every turn in its ambiguity and works out best for able-bodied, white, cisgendered candidates who will glean more success within the rostra.

Taking the plunge and actually becoming an escort has consistently worked out better for me financially and sexually. Although it's laced with a host of similar issues, I can set my rates de facto and say what I will and won't do. I can view other profiles and line my fee up accordingly. There's a two-way reviewing system by which I can see if others have given a John positive feedback, and I get reviewed too.

The *'sex work is work'* slogan comes from a place of wanting to have industry protection with labour laws, which, at the moment, isn't recognised by the UK.

The biggest downside of escorting is the stigma. Although it's not specifically illegal in the UK, people think being a prostitute is up there with being a hardened criminal — you never come back from that association. To openly live as a prostitute is to be unemployable, shunned and criticised at every turn. For you and your loved ones.

I wouldn't say the shift to becoming an escort is a place of resolve, and I don't want to make it sound all roses because the duplicity is hard work, but I've come to the conclusion that Sugar Daddy culture is the patriarchy at its ugliest. There are as

many renditions of sex work as there are sex workers and this, of course, is just my individual experience of it. But:

"Please Daddy, can I have some pocket money?" is not autonomy, it's not equality, and it's far from easy money.

Dear Mr Andrews

I'LL TAKE MY COFFEE SHRINK WHIPPED THANKS.

Chapter 1 – Mr Andrews

In one tiny flicker of a moment your expression changed. You'd cum.

All of the joviality fell away and everything about your body language said it was time for me to go. It's a look I know well from my time escorting. This wasn't escorting but that look is one I've seen countless times. It's the threshold between playboy frivolity and the heaviness of real life. That look is the *'Come Again Soon'* sign on the convenience store exit that is my pussy.

We met on a sugar site. I hit on you *(I think?)*. It's a long time ago now. I liked your profile and thought we'd do good chat. You asked if I'd be free for weekday hotel meets with a lunch thrown in. I had asked you for some business advice and help with getting a pipe dream off the ground. Whichever way you dress it up, it was a form of transaction. I admit, it was a leap of faith to keep it that loose. I'm normally strictly *ppm* but I thought I'd experiment with the format just this once. There was something about you that I instantly trusted.

I always find myself trusting people who hate the same things as me. Negative cohesion, right? I think we both disliked ourselves for pretending to give a shit about our media jobs; we're both victims of our own vanity in that sense. You asked the right questions and I held you in regard.

> *"Will you send me that legal contact of yours before you go?"* I said, rolling my stockings back on, sense-checking where we stood on our bargain.

You glazed over and patted your pockets for your keys/wallet/phones, your mind elsewhere. You'd just fucked me, bareback, in every hole, for free, at a time that suited you. Now you were standing in front of me looking vaguely hassled by my presence.

> *"Oh yeah, **that**. If I forget about it, then chase me for it next week."*

I'd lost my side of the bargain and left that hotel room expecting never to see you again.

I'd become a free hooker. I dwelled on it all week but then something bizarre happened and it subverted into a perverse joy. I started to really get off on how dumb I'd been to get duped, even after all these years.

At this point all reason would have said to walk away. But I began to text you instead. Compulsively, every day, multiple times a day. I developed a festering little crush on you as the wholesome upstanding citizen I could only hope to be. We established a new bargain. I'm going to call our dynamic *'a friendship'* but it's more like a muddy puddle. It's not true to say I lost faith in you; I've entrusted you with my entire life and you've given me a good deal of space to express myself. In this chat thread there are no good people and bad people — we're both entirely fallible human beings with a shared experience.

You joked that you were my *'paternalistic therapist'*. Ok, Mr Andrews, so you're my therapist, you know everything about me. Well, help me extrapolate some clarity.

Chapter 2

Lotte: *Do you ever feel like even though you've curated every situation that you've ended up in, that somehow you are still a passive bystander to it all just happening?*

Mr Andrews: *I feel that more now than at any time in my life.*

Chapter 3 – No Strings

In time, writing to Mr Andrews became a methodology. It felt really good to address my highs and lows to someone who's seen the world I circulate within from the other side. A total amnesty of information addressed to the perpetrator, the patriarchy, the paramour.

The following is a collection of key moments from my time escorting, and sugar-dating, divulged to the object of my affection. It's not all about sex though; it's about self-medication, societal norms, hypocrisy, dating, discos, Mr Andrews, and me.

I'd be loathed for you think Mr Andrews was the villain here. No, he's a curiously tolerant individual who can take a joke, on occasion. Think of him as merely my captive audience member. Who I'd also like to fuck.

I MEAN LIKE
IT'S NOT EVEN A
BIG DEAL TO HAVE
A SUGARDADDY NOWADAYS
LIKE EVERYONE
DOES.

Chapter 4 – Sugar Sugar

It's hard to know the extent of the truth but these sugar girls are fabled to be gushingly filthy and yearning for the touch of an older man. Yet, at the same time, nervously looking for guidance.

Lately, I keep getting photos of girls from men who fancy them. Bashful, young girls with pointy nipples. I'm collecting them like cigarette cards for compare and contrast. Maybe I'll make a 'Babes of 2019' calendar for next Christmas.

My Candy Girl account is five years old and has been ticking along in the background all this time. Along with a decline in the calibre of my conversations, my age has been increasing at an ever-steady rate. At 28, I am old.[1]

"Just lose a few years," my flatmate said.

Still might.

[1] Business Insider 2018: "The average Sugar Baby is 25 and makes $2,800 monthly from their Daddies." https://www.businessinsider.com/professional-sugar-babies-share-what-its-like-to-have-a-sugar-daddy-2018-7?r=US&IR=T

Chapter 5 – Predatory

Candy Girl is one of the few dating sites on which men have to be on guard from a glut of unwanted attention. One man, Andre, confessed to me he feels emasculated by this.

> *"Normally the man enjoys the chase and here it's quite the other way round,"* he wrote. Then, *"Crystal's a gem. She looks like about 16, or younger. Clever, young, naive. That's the way I like them."*

He followed it up with a photo of *'her'* freshly cream-pied pussy.

"She's really into that being raped by Daddy thing!" he continued.

I'd been talking to this man for all of thirty seconds. I blocked him because it made me feel uneasy. My creep threshold is high but those are big words. In these candid dialogues, they never mention the money that changes hands.

Ordinarily, I relish the gory details but I'm beginning to fatigue.

THE
BANK THAT
CARES

Chapter 6 – Pussy Broker

Dear Mr Andrews,

I've been spamming you for a while now. In all earnestness I quite fancy you. You provide tasteful dirty talk and have absolutely no interest in me whatsoever. It's a tension I can pursue safe in the knowledge that it will go nowhere. If anything, something about you fulfils the deep-seated need I have to be rejected.

I had sex with you for free thinking… it would come back to me in karma?

My friend Valentina said: *"What!? You offered sex out on credit? Are you the bank of pussy or something? That's a terrible idea!"*

After our rendezvous, it was late in the afternoon and already dark outside. I sat on the hotel stairs looking at the moon through a white wine bottle. Truly wondering if I'd lost control but feeling kind of neutral about it.

THROAT G.O.A.T.

Chapter 7 – Consumer Culture

Maybe to take pleasure in corruption is a human instinct. Is it the equivalent of buying a Collin the Caterpillar cake from M&S and eating his face off before discarding his hindquarters? Pure consumptive enjoyment for £7.99.

7% of college students are now in the adult industry.[2] Percentage-wise, that's far greater than the number of people on the campus netball team. This is real everyday occurrence.

#sexworkisrealwork

The thing about sugar dating is that it isn't sex work. It's like being a waitress who only gets paid tips — plausible deniability

[2] https://www.savethestudent.org/money/covid-19-student-survey.html#income

in exchange for no parameters. But I'm left wondering: if casual prostitution was normalised, how would that play out?

An acquaintance once proudly told me that she had recruited three of her uni friends.

> *"I wouldn't want that responsibility,"* I grimaced.

> *"It's been great for my self-confidence. Why shouldn't I spread that joy around?"* she said.

We left it at that and went back to comparing notes on our daddy issues.

MMF ACRO YOGA

Chapter 8 – Parallel Lives

I have a civvy job too.

I went away for a conference in Newcastle and checked into a hotel. I opened my laptop and logged on to Candy Girl. *Let's put this room to use*, I thought and felt stupidly turned on by the swirly caramel carpet. It's always the fucking carpets. I've grown a Pavlovian response to them.

Newcastle, is not London. It's not oversaturated with pretty babies.

I propositioned three men and one replied: *"Are you an escort?"*

I said: *"Not exactly but I moonlight."*

He said: *"Give me a message Monday night if you're free."*

The simplicity of it! Just like the good old days.

But I felt too guilty for turning tricks on a business trip. Instead I worked late, got drunk, and eventually ended up in bed with a colleague.

Chapter 9 — Dept. Store

For a time, I observed a 'proper' job as a window dresser in a British department store. This highly coveted but poorly paid position turned out to be mainly administrative and entirely a dead end.

One day we received a bulletin to our intranet inboxes:

> *Dear valued staff member,*

It has come to our attention that prostitutes may be operating around the building at various restaurants or bars including the ground floor champagne and oyster bar. Please report suspicious behaviour to your line manager if you witness anything unusual.

Apparently, it had become a popular meeting point for call girls. I suspected the gripe had originated from a shareholder, concerned that the store ought to shed the Knightsbridge playboy reputation it was beginning to accrue.

After reading the email, I sacked off the rest of the day in favour of a slut safari to see whether I too could spot these untoward entities. What a strange email! It was all I could do not to demand clarification. What does whoring look like? Thigh high boots? Propositioning? Wads of cash?

Mission aborted, there was nothing to see.

I got home from work that day and started an online investigation instead. After having not fucked a living soul for nigh on a year, I found almost everything erotic. It was the kind of dry patch that instead of ambivalent left me deftly wanton.

I read through the Craigslist personal ads and got wet from all the crude language. I answered a couple of adverts with a fake email address, touching myself between typos, then deleted all evidence of it, abashed at my boldness.

Over the next couple of weeks, I researched the options. I looked at some London escort agencies but I didn't look like of the girls: Saint-Tropezed, fish-lipped and extensioned. I'd have been a mousy anomaly next to their porno chic. Also, I wasn't a

teenager. I was well into my twenties. For some reason, I assumed if you were going to try that sort of thing you'd start early. I titillated myself with *should I? shouldn't I?* looking under rocks to see where the depravity dwelled. Eventually, I landed at a sugar baby site called Candy Girl.

For better or worse, it seemed like a safe entry point. I was guarded at first and felt that if anyone found out my life would be over. There were a lot of abrupt messages demanding nudes but generally the conversations were congenial. I happened upon Mr Castle who was just what I'd had in mind: enticingly perfunctory and looked like everyone's father I knew growing up. The dry dads-of-friends who weren't comfortable being in the same room as their daughters' friends. I felt I would be able to suss him out.

I got ready for my date in the work toilets, putting on stockings and a little black dress. It was fairly amped up for a Tuesday night but it was the kind of outfit the girls wore in the fine jewellery department, so for once I didn't stick out like a sore thumb in the canteen.

I winked at the sticker on the emergency pantyhose dispenser on my way out the door:

Dress for the job you want not the job you have.

Dangerous words indeed.

Mr Castle didn't say much when I got to there. He was aloof and unimpressed. I had to do a lot of the leg work, nervously giggling between anecdotes. I looked like I might be related to him and wondered if that's what people would think. I've grown

18

to love a judgemental look from a bystander but I used to find it really embarrassing. It reminded me of having dinner with my dad when I was growing up. How people used to roll their eyes. Another middle-aged man with a stupidly young girl. I looked older than my age and have always had a bass-notes of tart about me even from pre-pubescence. Which was made worse by my mother always insisting I ask him for cash for the arrears he'd failed to cover in his alimony. More often than not there would be a financial exchange with cash handed over the table.

Mr Castle asked what I wanted and I said:

> *"I want you to pay me and then you can do whatever you want."*

> *"For sex?"* he said. I nodded.

I found it hard to get the words out but once he'd agreed I was surprised at how easy the exchange was. We didn't talk figures, but he said he'd arrange a hotel room for next time. He kissed me and pressed £100 quid into my pocket as he put me into a taxi.

Turns out, this was a misleading encounter. After the success of Castle, I tried out someone else and it couldn't have played out more differently. This strange man, who had described himself as an Ivy League marine, was about 5'6" and walked with a limp. He took me to a deserted cocktail bar a quarter of an hour after it had opened. We sat opposite the bar with the bartenders looking at us, and me looking at them, and him licking his lips and staring at me. Pin drop silence. He, a god-fearing man, didn't agree with money changing hands but said:

"My little cupcake, I want to take you out for dessert."

He took me to the restaurant next door and bought me a knickerbocker glory. I accidentally dripped it down my cleavage, and he dived at my breasts to lick it off. The table adjacent looked on with disgust. I looked at them with disgust, then we all went home.

Back at my day job, everything was getting smoother. This little kick of anti-establishment middle-fingering was enough for me to feel harmonious. The routine window cycles and the routine hangover were both more tolerable now that I knew I was defying in some way.

I had my reservations though. Was I going to hate myself for it?

Whore is one of those terms that once used is irreversible. Murderer being another. They are state changing labels. If you've done it once, that's what you are forever, by Daily Mail logic at least.

On the day of my second meeting with Mr Castle, I was so nervous that I felt violently sick. It was all I could think about. I took myself for a turn around the store to walk off the nervous energy. By the time I was in the cocktail bar with him, I could only look at the floor. By the time I was in the lift with him going upstairs, I was physically shaking. I'm not sure what I thought was going to happen but I was debilitatingly afraid of it.

When we were alone in the hotel room he pressed the remote control on some risqué red uplighters, meant for such occasions no doubt. He stripped my dress off and told me he was going to

turn me into a slut. Then he fucked me really hard, which was a tremendous release on my part, and said:

"Now you're my whore."

Looking smug, he reached for his wallet and stuffed a bunch of fifties in my stocking tops. The whole thing was over within an hour and a half and before I knew it he was flagging me down a cab.

When I got home, I emptied my handbag onto the bed. He had paid me £500. I normally don't reel at cash perks but window dressing doesn't pay all that well. In short, no, I didn't hate myself for being paid for sex. I felt attractive for the first time in months and a little more solvent because of it.

At work the next day I had a throbbing hangover made all the more pointed as it was an install week. They had blacked out the windows, as they normally did, so we could work in the cavities behind the glass. I was with Sefina, one of the senior dressers, who was teaching me about the ancient art of window dressing, Saks 5th Avenue style. How to prop a mannequin with a hammer and nails, upright, no spigot. How to monitor what you were doing by looking in the reflection of the glass. Sefina was the traditional type; she would have hated to know what I was getting up to after work. I would never be able to convey to her that it was the only thing keeping me sane.

Getting braver with my hobby in no time, I tried a similar arrangement with a man called Paddy, an American in town for business. We'd agreed over email to have a transactional shag at his hotel. The plan was to meet at Claridge's Hotel for a martini. I got changed in the tube station nearby putting all of

my belongings into one of those overpriced lockers. Obviously, when he told me to meet him at Claridge's, I believed that's where he was staying. He was actually staying at an Ibis down the road.

Paddy really reckoned himself and spent a long time bragging about how angry his wife would be if she knew. He seemed glib that he was pulling a fast one, and maybe I was equally glib that I was pulling a fast one. We deserved one another. He'd met his wife at Stanford. She was an economics student who used to strip on the side.

"Brains and beauty," he said.

It sounded to me like she might have the mental capacity to figure out what Paddy was up to. I imagined she was choosing to turn a blind eye. You could tell he was the sort of guy that liked a girl who'd been around. He wanted to know:

"How many men have you slept with?"

I didn't answer because the truth would have been disappointing.

Paddy was pounding into me up on the 14th floor of the Ibis. He paused for a fraction of a second, touching the perimeter of my asshole. Then he whipped the condom off and shoved his cock up my ass with a happy-go-lucky gasp.

I hadn't agreed on a rate with Paddy. I just picked up the envelope as he ushered me out the door. It felt lighter than what Mr Castle had given me but I didn't mind. On counting up the notes in the elevator, it turned out he'd left me eight tenners and

a fiver. £85! For stealthily blowing his unsheathed load up my arse.

As I walked off the rage on my 20-minute stomp home from the tube station, the anger turned to pleasure. I'd gotten to be the cheap bareback *'fuck you!'* to the world I'd always wanted to be. That perverse joy is a facet of my personality that scares me. I'm aware that I use my body as a weapon when I feel backed into a corner. I've yet to decide whether that's a strength or a weakness. Or both.

One day when I got to work there was a Post-it note on my desk: *Please call Sefina.* I rang her back a few hours later as it wouldn't have gone in my favour to look too keen. The art of looking busy when you're not is a subtle skill that needs to be built up over time.

> *"I need to have a talk with you,"* she said. *"Don't worry, you're not in trouble."*

(I was)

> *"Ok, I'll come over when I've finished with this."*

By *this* I meant taking selfies of my arse in the disabled toilet. I sighed and walked slowly down seven flights of stairs, the long way around, then made my way through the underpass, past the lockers, past security, to where all the proper employees lived.

> *"Hi, Sefina. You wanted to see me?"* I said, doing all I could to restrain the schoolgirl in me.

"Yes, I have to tell you off, you naughty girl. It's your punctuality!" she said and raised her eyebrow. *"You have a 95% late record!"*

Sefina pulled out a piece of paper with my clocking in/out times.

"Let me take a look at that!" I said, impressed by the traffic light colours on the spreadsheet.

"7:30, 7:30, 7:31, 7:30. It looks to me like I show up on time-ish every day."

"Clocking in on time means you're late. My dear, you are required to be here before your contracted hours. You should really be starting your rounds at 7:30. I don't want to have this talk with you but everyone else seems to manage it. And if you can't stand by that, then you might get your staff perks retracted. Is your 10% staff discount not worth turning up five minutes earlier?"

"But you only pay me between 7:30am and 4.00 pm," I said.

Fuck the 10% discount. I'd trade it any morning for 10 more minutes in bed. I always thought it was a poor sweetener for getting us to reinvest our wages back into the business. Staff policy required that every day, I ought to appear customer facing. I found this challenging as I'm naturally turned out like a bird's nest. Even on the days when I'd risen to the occasion, I'd fuck it up by backing onto nails or soiling my workwear with hot glue and white emulsion. And when it wasn't my appearance, it was my actions. I'd mistakenly flash my knickers whilst up a ladder facing the main road. And I got caught several

times pretending to finger a mannequin. A game I found endlessly hilarious.

I left Sefina's office feeling like my days were numbered. However, I continued to turn up on the dot at 7:30am and not a minute earlier.

One autumnal day Mr Castle invited me out to lunch. I managed to wrangle myself a half day so I could meet him. I'd seen him a few times since our initial meeting. Twice in a hotel, and once at his house. This time he recommended an Italian restaurant in Soho. It was traditional in that amped up white tablecloth and vongole kind of way. We chatted about Brexit; he didn't think it was going to happen and I agreed with him. Then he walked me around the corner to the Agent Provocateur boutique.

> *"I'd like you to pick out some underwear but I don't have long. I have to be back at work soon,"* he said.

Someone with a fat wallet takes you to a shop and tells you to buy anything you want. It sounds like the most decadent situation but my stomach was all tied up in knots. Lingerie, for me, is a curated occasion. I don't want people to see my buxom failures, or something that cuts me up like pork loin. It takes some trial and error. I fingered the options, looking for something that might suit.

> *"May I try this on please?"* I asked the shop assistant.

> *"In what size, madam?"*

> *"I don't know. I'm like a 34F normally, so something around that?"*

25

"Ooh, we don't have much available in our larger sizes."

I resisted the temptation to launch into a rant.

> *"Ok, could you just bring me a few options please, anything,"* I said with a hint of desperation. *"Actually, bring me the most expensive things you have in the largest sizes, if that's possible."*

Sat in the armchair reading the news on his phone, Mr Castle began to check his watch. I was so clearly hating every moment of it but I don't know how much of that he could read. The lady brought a couple of options into the changing room but they were terrible.

> *"We don't really keep much in an XL. Maybe a cupless bra is your best bet?"* she said and helped me into something with lacing. I looked down at my breasts knowing full well they weren't going to stand to attention without scaffolding in place.

Feeling the time constraint, I made a snap decision. I chose the most expensive thing on the menu: a corset wiggle skirt and bra combination with stockings. It came to just under £1000. I told Mr Castle I'd show him when I saw him next. He kissed me on the cheek and rushed off to work.

I waited for him to call, but he didn't. He didn't see me again at all! I'd go as far as to say he dumped me with nearly a grand's worth of underwear and never took pains to even see what it looked like on me. Maybe all he'd wanted to do was make a whore out of me and fuck off to the next girl. I smiled to myself thinking what a fabulous man he was and fanaticised for months

about who he might be defiling next. He had, in a way, set me up ready for business.

Shortly after that, the department store gathered everyone together to drop the bombshell that they were going to rent out the Christmas windows. Devastating news. It sounds feeble, but if you care about window displays then Christmas is everything. I used to come to London to see the windows when I was a kid, in pyjamas with my mum. Looking back on it, I suppose it was a crass celebration of the commercial holiday Christmas has become. But it was delightful and probably why I'd ended up in the job.

> *"But what about the people who come to see the windows?"* I blurted out.

> *"The tourists who come to see the windows aren't the people who spend money in store. Our highest spending customers want to see brands and that's the demographic we cater to."*

Their highest spending customers are also the ones buying perfume for their mistresses, lingerie for their whores, and guzzling champagne with their sugar babies. Sefina looked heartbroken. We side-eyed one another like banshees ready to blow.

It seemed like a good time to split. I trotted down to head office to hand in my letter of resignation. The manager told me to stop looking so happy about it.

IRONICALLY VALENTINA AND I MOVED ONTO THE SAME STREET IN BERLIN, IT SEEMS WE COULDNT GET AWAY FROM ONE ANOTHER. *

Chapter 10 – Hole in the Wall

Valentina and I had been living together in London for five years. If we'd been romantically involved, we'd probably have ended it. But instead, we stuck around to stick needles in one another's eyeballs. It was the kind of acrimony that could only be fuelled by fervent friendship and damp British housing.

I've always had these penetrating female friendships that invade every area of my life like mistletoe on poplar trees. It's beautiful and suffocating. Actually, I'm the parasite, not the host animal. People thought of me as her bitch, almost since day one.

> *"You're not my bitch. You're like a marshmallow with a bullet centre,"* she said.

The landlord was doing work on the house. We stood in the kitchen at the back of the house looking at the empty space where a wall had been the day before. The flapping tarpaulin picked up with every gust of wind. There was a layer of brick dust all over our belongings. Once this wall had been rebuilt, we both surmised that we would be evicted.

"I'm leaving," Valentina said.

"But I love you," I said.

"I'm moving to Berlin, with Electra. This city is cunted!"

"I'm going to Berlin too."

"Do what you like. I'm going without you."

We moved to Berlin, separately.

Chapter 11 – Jean Laurence

Lotte: *Did I tell you about Jean Laurence already? I forget. He's the happiest man on earth.*

There is a lot to be learnt from the prosperity of a person whose magic ingredient is not giving a fuck. Not long ago, I read some interviews about people who had lived to be one hundred years old. Amongst them were devoted followers of yoga, active grandparents and country air enthusiasts. One interview stood out from the others: a man who insisted the secret to immortality was never worrying, a pack of Luckies, and a generous slug of scotch. Jean Laurence was a follower of the same creed. As a father, as a lover, as a smoker, his remit was to do exactly as he pleased.

As soon as I saw his advert, I knew we'd end up living together. In a picturesque way, it seemed to be perfectly Berliner.

ARTIST SEEKS FEMALE FLATMATE, UNDER 30,
PRZLBERG

The apartment is a beautiful Altbau. I have lived here for seven years.
I built the interior myself. The room has a Hochbett and is furnished.
I am a photographer who specialises in erotic art and my studio is at home.
Girls only — *please do not apply if you are close-minded.*

I went to view his flat in a virginal white minidress and a little flower behind my ear picked from the park. If he wanted a girl, I was more than happy to oblige. Jean Laurence was a ruggedly handsome 53-year-old Frenchman, an artist, and a pervert. He smoked continuously, grunted dismissively, gesticulated wildly but most pertinently he was the worst listener I have ever met. Entirely tone deaf to the world outside and happier for it. I liked his strength of character. He pointed me down the corridor to take a look at the room. I pushed the door open and a puff of herbal smoke emerged. A girl with white dreadlocks stirred from a pile of cushions near the window.

"He's a complete arsehole. Don't do it," she said.

I disliked her hotbox, and her hair, so I decided not to heed her words. The room was dark but the ceilings high and it was in a pleasant part of town. I became enamoured with the flat when I saw the collection of crystal-cut champagne glasses. A delicate display studded with the occasional Venetian glass butt plug.

31

He offered me the room on the spot. I hesitated because it felt hasty. Then he sent me a message:

> "*I'm crazy and have to be with crazy people. Life is too short to be bored.*"

I took the lease without further mulling it over.

Jean Laurence built sets at the opera thus his taste was quite theatrical. With an impeccable eye for objects, mostly of French origin, he regularly returned to the house with things he had found in the street or the local antiques market. Quickly I came to learn that he collected girls too. The phrase '*a great lover of women*' is apt for Jean Laurence, in fact it was part and parcel of what being an artist meant to him. His craft was bound to ephemeral beauty and his specialist interest was photographing what he called '*The Rose of the Night*'. He saw the female orifice as '*a vessel of mystery*' which he would chase but would forever be elusive.

I found the entire charade objectifying but the girls seemed to love it! Internally I reconciled our artistic differences because nearly all of his models were heinous victims of their own vanity. In this fortuitous manner, he was living the life he'd always dreamed of as a young boy — looking up girls' skirts.

It wasn't long before I took on a subservient role. I was quite enjoying the #tradwife roleplaying. He'd go to work and I'd go to German school. When I returned, I'd write stories, watch porn and clean, then I'd make dinner. I felt like Snow White.

That first summer in Berlin was the honeymoon period. I didn't feel like I had to do anything much. I just enjoyed the city for

its best bits: wild nights out and making friends with poets in the park.

On the morning of Jean Laurence's birthday, he declared over social media:

"*Pour mon anniversaire, I would like every girl to send me a picture of her pussy.*"

I watched as girls responded to the statement by attaching selfies of their young cunts. By the end of the day, he'd amassed thirty private pictures and one wank-vid.

His favourite hobby was to entertain his female flock and since it was his birthday, he was planning to do just that. He decided to make pancakes.

"*Not pancakes, crêpes,*" he said, correcting me.

I watched the stack get higher and higher. They had a clammy texture like when ball sacks stick to thighs. We weren't allowed to touch them until the guests of honour had arrived, Layla and Danielle.

"*Ah, the girls… always running late,*" he laughed.

Stéphanie was sat at the table already. I liked Stéphanie. She had a gruffness which didn't suit her body. Earlier that week she had dropped off a bottle of wine in gratitude for Jean Laurence's help, which she promptly began drinking the moment she arrived. Her car had been impounded and he had volunteered to pick it up. Evidence alighted that it was not the first time she'd crashed but this time they had relinquished her of her license.

Tatyana, who had been showering for half an hour, emerged from the bathroom in a halo of steam, fully made up with a fresh set of clothes. She had been staying with us for nearly a fortnight. Apparently, Jean Laurence met her at a party after she'd had a fight with her boyfriend.

Jean Laurence was endlessly generous with his quarters. I don't think he was bedding all these women, well maybe Tatyana. In fact he rarely had sex but he certainly enjoyed all the ladies decorating his apartment. Once, as many as seven girls were staying with us in the two-bedroom flat. One time I returned from a trip to London and former Miss World Bikini was sleeping in my bed. I kid you not!

Hotel Laurence was much like a scene from a Fellini film: a host of models crowding around one well-lit mirror in states of semi-dress. They lent each other nail varnishes. They recanted their heart break to one another. They shrieked to their friends on the telephone and giggled at the saucy props in his room. He remained in constant bliss at the centre of this whirlpool.

Layla and Danielle arrived. Both were aspiring actresses with striking swathes of hair and the blushing lips of a Pre-Raphaelite muse. They sat down to the stack of crêpes which was starting to tilt off centre.

After dinner Jean Laurence flicked through a slideshow on his laptop of a photoshoot with Layla. Some whimsical pictures of her naked torso on a backdrop of ivy. Notably envious, Danielle expressed an interest in modelling too.

"It would be an honour to work for such an artist! This picture here, this says everything! Just eyes and pussy. All a woman needs."

"Let's all dress up!" Layla said.

Jean Laurence pulled out a pair of slash-crotch bloomers and a glass chamber pot. He wanted to photograph Danielle in a vulnerable moment: a maiden crouching with her hair grazing her thighs, not knowing she was being observed by a voyeur through the keyhole. She shook her head.[3] No peeping Toms for her.

Next, he pulled out a flamenco dress covered in sunflowers. The dress sat taught on Danielle's waist and framed her shoulders, accentuating her feminine form. She and Layla twirled around until they nearly set fire to the flamenco dress by dancing too close to a candle. They screamed.

"Uh oh! We need to go," Layla said, checking her phone.

Jean Laurence looked wounded, but the girls had to go to work as they'd landed jobs with a tobacco company giving out cigarettes in return for email addresses. He asked for Danielle's contact details so they could arrange a shoot then made one last toast to:

"Eternal beauty and art!"
"Prost! Santé! Cheers!"

[3] He loved to watch women urinate and had described it to me at length.

The happiest man on earth slugged his last sip of whiskey and went to bed.

Living with Jean Laurence seemed like a rite of passage in Berlin. There's a naïve optimism about the city which feels old-fashioned. People make art like no one's watching. The graffiti quotes Marx. There's no vomit on the U-Bahn.

There were no luxury fucking department stores in my field of vision. Nothing but art. And sex. And drugs. And dancing. And rectangles. And bars that gave out free peanuts.

Although it didn't last between Jean Laurence and I, I lived there for a while.

At a certain point his foul temper and bad art started to grate on me. He said I drank too much coffee, too late in the day, and it wasn't to his liking. After a while, even the fact that I didn't go to work began to bother him.

"*But I am working, as an escort!⁴*" I said one day.

"*Ah ha! I used to be a gigolo,*" he said and laughed.

It figured.

⁴ I'll get to this in a bit. The laws are different in Germany. It's a bit more legal than the UK and consequently the face of prostitution looks different there. Less silicon, more various. Sex work seemed like a viable option in Berlin. **Something** you do. Not, **everything** you do.

RABBIT AINT GOT NO TAIL ATALL
TAIL AT ALL , TAIL AT ALL.
RABBIT AINT GOT NO TAIL
AT ALL JUST A
POWDER PUFF

Chapter 12 – Hans

When I arrived in Berlin, my plan was to have no plan.

At first this escort agency called Rubenesque dangled in front of me as a bit of a joke. An agency for fat girls. I thought about it. Was it really any different to having a man stealth me[5] for eighty odd quid? The agency took 30% but I was in a country where I didn't speak the language and so it seemed prudent to lean on a middle-man. I figured that if I was ever going to try proper escorting it made sense to do that in Germany where it was less taboo and more legal[6]. I wrote to them expressing my interest. They got back requesting an interview.

[5] Stealthing: removing a condom without consent, which is considered rape under UK law — just sayin'.

[6] Prostitution in Germany is legal nationally but regulated locally. Most regions have designated areas where sex workers can operate and fines for non-compliance. Berlin is the only city free of these restrictions. In 2017 a bill called Prostitutionsgesetz or ProstG was passed making it compulsory

I found myself in the leafy suburbs of southeastern Berlin in a bright shop decked out in royal blue carpet tiles and slash blinds. It was called Fotowelt.

The glass doors were etched with a frosted logo and the walls emblazoned with posters making offers such as:

Lose 50kg... with FotoFX

I sat at a table waiting for Peter, the man behind the well-oiled machine of niche sex work. I'd expected to be hustled into a windowless office with two or three shady looking men peering over a pile of biscuit crumbs. I'd anticipated flecked partition walls and the smell of a microwave kept within a confined space. But it was more like an estate agent's office. There was even a bowl of nut fondants near the door.

Peter came across like a car salesman; encouraging me to improve my German for maximum yield and reassuring me the company was one hundred percent solvent. Sex was not important to him. It was a mere formality.

He told me, in a business-like manner, that the company was built on a foundation of respect and dignity. He described how the owner had discovered '*the fetish market*' and untapped goldmines within people's dark fantasies. He shook my hand and gave me a contract to review. I didn't sign on the spot. He said I could take all the time I needed then booked me for a photoshoot that Saturday.

for prostitutes to sign up to a register. I never did for fear it would come back to haunt me.

On my return, clutching my signed contract, I expected to see Peter again with a photographer or colleague. Instead, Hans answered the door. An older, bronzer, squinting kind of a guy.

He was the owner and liked to photograph all of his girls personally. It was his favourite part of the job. He invited me in and showed me to the same seat. But he wasn't welcoming like Peter had been. He looked at me with suspicion.

Hans printed off a double-spaced list and handed me a ball point pen. Realising how little German I could speak, he switched to English. It was a 'ja/nein' questionnaire of sexual favours. When I was done ticking boxes, I handed it back to him. He paused and said:

> *"It is imperative, if you meet a client* (he cleared his throat) *ein Kunde and you feel you cannot follow through with something that you've ticked yes to on this list, then you must cancel the appointment within five minutes. Or else it becomes very* (he wrung his hands mafioso style) *tricky for us."*

I don't personally believe in sexual imperatives and was vexed to hear the swollen concern in his voice over my 'Prix Fixe'[7]. It

[7]'Whorearchy' is a term describing the discrepancy in pay and working conditions between so-called 'high class' and other sex workers. According to the House of Commons 2016-17 Prostitution Report: "Sex workers have an average of 25 clients per week and an average of £78 per visit." This has never been my experience. From a place of white girl privilege, and thanks to my posh accent, I have mostly been paid into the hundreds and have never taken more than two or three clients per week. I'm sure that escorting has as many iterations as workers but I have never been paid for 'the act' explicitly but rather for my time.

had been my understanding that although sex was implicit, technically the clients paid for the time not the buffet.

"Any questions?" he said.

"What's Natursekts? Is it like sex outdoors?" I said as I ticked yes.

"Nature's Champagne. That's what you might call Golden Showers."

On hearing those words being read aloud by a serious German man, I stifled my laughter. It felt like an educational guide to Dirty German. He read on.

"Fuss Erotika. You haven't ticked this box — but it is only for feet. You maybe misunderstood?"

"No, I understood. I'm just not really into that."

He stared at me perplexed.

"Why not?"

"Does it make a difference?"

I didn't like my feet and could think of nothing worse than controlling my disgust as I watched someone playing with my dwarfish leg stumps. I have the kind of soles that take on an iodine stain and my callouses are perma-hardened through neglect.

*"Lesbian. You might have to **actually** do this if the man desires to see you with another woman. Will you be able to follow through?"*

"Yes, of course."

"And lick her too?"

In a city that sported sexual liberation as a tourist attraction, it seemed archaic that the concept of lesbianism might only exist hypothetically for male consumption. This being said, Hans was hardly a modern man.

"Rasiert. Your answer will not work. You have to choose between shaved or not shaved."

"I wax."

"Could you shave?"

"No."

His forehead twitched as he circled my answer several times then chose the *'nonrasiert'* box.

"The problem is, I don't know quite where to put you. Rubenesque is for fat women and you are not that. But you're not the size of our normal Salome girl either. Does Devot from our Bizarre range appeal to you?"

Devot, or being submissive, extended beyond my comfort zone. It seemed a bit too intrepid to line oneself up at the abattoir of paid pain. I declined in favour of Rubenesque. I was quite

41

endeared with its golden glow, its calligraphic cursive and depthy cleavage header. It seemed operatic.[8]

I followed Hans to the back room. It contained: a Hollywood bulb-frame mirror resting on top of a laminate table, a coffee machine, and a sofa with yesterday's rubbish bags leaking into the cushions. It smelt of musty teabags.

I didn't know what to wear for my shoot. The other girls seemed to be wearing mostly lingerie so I brought my favoured under-items *(bought for me by Mr Castle circa 2016).*

 "Where are your business clothes?" Hans said.

I looked at him confused and he pointed to some glossy portraits of buxom wenches in blazers and tight skirts.

 "You must own some business attire. All of our girls are professional."

Something about the way he sucked air through his teeth gave me the impression he was pretending to be more difficult than was necessary — maybe in order to yield obedience. I disrobed under his attentive gaze and declined his offer of assistance with my suspender straps.[9]

[8] After establishing Salome, a successful middle-of-the-range escorting site, Hans branched out into the older lady market with Eleganza (escorts 35+ in various degrees of mummy to dominatrix). He then established Rubenesque for men who like Dicke Titten and roomy behinds. Snow-Bunnies was his barely legal range of teen sluts, the most expensive girls on his books. Lastly, he launched Bizarre for anything else fetishistic, including two transexuals and a lesbian couple with a truncheon.

[9] Hans would have fit in with any red-light district world over. A pimp through and through.

I am wary of pimps. The summer before I had been chased by a street pimp across a children's playground. I had been watching in fascination as the hookers on the K-damm walked the curb in black underwear, neon fishnet body stockings, heels, white hot pants, and chokers. The bold costumes were striking but it was their movement that interested me most. Each girl chose a car and walked the length of it with such assertion as to create an 8-step catwalk, clucking at young male passers-by.

At one point, the elfin girl walking the length of a BMW stepped aside as an irritated man retrieved his car. With a disgusted look, like she'd soiled it, he turned his key in the ignition and drove away. She didn't seem to notice but instead moved along to the next parked car and invested her presence there. Hand on one hip, hissing at the competition, she unapologetically created an obstruction in the cycle lane.

Slumped over the electricity box, I watched for hours. Then I got up and followed one of the girls who seemed separate from the rest. That's when a man started following me. A wiry, messy-haired, hunched-over man with brown teeth and a white t-shirt. He was clearly in pursuit of me, so I sought refuge in an eerily empty, air-conditioned furniture shop.

After five minutes, I re-emerged with a lemonade. He was still outside waiting for me. I crossed the road twice to affirm his chase wasn't fabricated in my mind. Then I started to panic. Reasoning that it had been my own fault and he was just trying to chase me out of the area, I tried to stay calm. Maybe he thought I was a non-uniformed police officer. Or worse, maybe a Christian. Or a vigilante. Or he just didn't like me. I took a brisk right into a children's playground.

With my breath quickening, I looked behind to see if I'd shaken him off but, if anything, he was closer. Maybe twenty feet away and reaching at something in his pocket which I feared to be a knife. The sand pit became an obstacle. Where my step had been light on the tarmac my feet now dragged in the dunes. I trotted with my knees high and my skirt pulled up, then took one last look over my shoulder, bolted the thigh-high fence and legged it the last two hundred metres to Schwules Museum, Berlin's LGBT gallery. **Thank God for the Gays!** I paid for a ticket and ran into the *Queers in Theatre* exhibition as fast as possible. Thinking, rightly, that the pimp wouldn't follow me into a queer space.

Hans leafed through his selection of flocked-rococo backdrops then walked over to his office and pressed play on the stereo. That Amy Winehouse song 'You Know I'm No Good' started playing. I asked him about the record in an endeavour to make small talk.

"You like British music?"

"Oh, Amy, she's a true artist of our time," he said and began taking pictures. *"London is where the heart of rock and roll is. I want to go back and explore Amy's Camden. I feel I have only seen the tourist's city so far and I know there is so much more!"*

Hans stretched his arms above his head between shots. He took long breathes to help his creativity marinate. By the third or fourth outfit change he was grabbing at a pair of braces and a captain's hat. Then he reached for a plastic venetian mask and a biker-jacket. It was no surprise he was angling at a retro look with my tacky ginger dye job and set hair.

44

He changed backgrounds from black to white to red, asking me to throw my head back in the throes of rapture. I am not a natural before a camera. In fact, I find it invasive and never have any idea where to look without buckling my lip at the last minute. However, I understood that unless I responded favourably, I'd be there all day, so I pretended I was a glamour model — straddling boxes and flicking my hair whilst provocatively placing my hand over my crotch.

Under the hot lights, I noticed my nipples were puffy. I tugged at them and tried to perk them up a bit. Hans walked over to the fridge and grabbed me a can of lager and a Rotkäppchen miniature.[10]

With a beer can on one breast and a mini champagne bottle on the other, we took a break. There was still one more shot, which required a bottle of coconut body oil. I slipped into the bathroom and poured it over myself. Mixed with the smell of hairspray, it was like the Malibu-breath on an underage drinker. The poses were lit up at the edge so the contours glowed, causing most of the bulk of my thighs to blend into the background, somewhat misleadingly. This was what Hans called his 'boudoir lighting'.

When it finally ended, I reclothed and joined him in the reception to flick through the album. We agreed on a short list and that my face would be hidden or blurred for privacy. I nervously waited through the weekend as they promised they would contact me to proof my page before going live.

[10] Rotkäppchensekt is the DDR equivalent of cheap fizz. I love it! The dry one is very tasty but the sweet original is like Babycham. It comes in a neo-classical red and gold packaging with calligraphic label. Very Rubenesque!

Having heard nothing from them, I went online to check the Rubenesque website. There it was: my plus-sized profile live, with no blurring, and several full-frontal face shots. I had been described in lusty German as:

Lady Lotte — Charmingly submissive with an interest in Jujitsu.

YOUR PET OF CHOICE IS A PRAYING MANTIS!

Chapter 13 – Radio Silence

Mr Andrews answers about one in every ten of my messages. If he hasn't answered for a while, it can be disheartening but I soldier on.[11]

Dirty German? A Pimp-chase? Coconut body oil?

Nothing.

Sometimes one has to change up the pace to get a response.

[11] Mr Andrews and I had become pen pals. I'd bombard him with messages and he would seldom answer. Every time I thought he'd blocked me, he'd come through with a quippy remark before I lost hope. We arranged to meet a dozen or so times but each time he'd cancel at the last minute or turn his phone off. Then I'd wank about it. But I always kept sending texts. Sometimes he replied. Sometimes he didn't.

Lotte: Do you have a pet? Do you want a pet? If so, which pet would you have?

Mr Andrews: I smell desperation in your tactics to get me to respond. I'm sorry. I'm busy.

Lotte: Desperation! Is it desperation if you know you're doing it?

I felt you were a dog owner. Yap.

Let's keep going.
My fateful undoing from sugar baby to escort.

Chapter 14 – Rubenesque

FAT WHORE. It's a strong image, no?

When my first customer came around, I was terrified. In my mind, the Rubenesque client morphed from hedonist to horror as I wound myself up in the four days leading up to my appointment. I mean this wasn't just some guy looking for a bit of jiggle. This was someone who'd typed BBW escort into Yahoo. He'd surely be a Feeder, a fetishist, a pervert in the highest degree.

I tried to tell myself it was just like any of the previous encounters, but it felt different. First, it was temporal. A two-hour appointment beginning at 11pm. Second, there was no

buffer zone of meeting at a bar to get a sense of one another. Straight in there — sex implicit.

Upon arrival, I was confronted by the issue of the lift.

The customer wants you to meet them in the room, but you can't get up to the room without a key card. SO, you wait until someone calls the lift and pseudo-confidently stride over to hustle along in there with whomever's riding. Simply ask them to press the button for you.

As this was the first time, I didn't know what to do. I panicked and the concierge keyed me up, no questions asked. Maybe they could smell how green I was. I hovered outside the door in the empty corridor. It took every ounce of composure I could muster to pull myself together and knock. As I waited for a response, I suffered the intake of breath caused by dominoes set in motion.

"Hallo Lotte, Lott-a, Lott-ee?"

Once the man opened the door, the nerves melted. But that exquisite shot of adrenaline over not knowing who might answer was orgasmic.

"Hallo, Martin?"

"Ja klar."

"Ich bin Charlotte. Ich komme aus London und mein Deutsch ist Schrecklich! Entshuldigung sie. Could we speak in English please?"

The recklessness of stepping into danger and being beholden to whomever stands behind the door is a massive turn on for me. In one instance I orgasmed out of pure disgust at what I found.

> *"Oh! You could do with being a lot more voluptuous,"* he said as I sat down on the sofa.

He was sweet and only subtly kinky. I felt very much at home.

A petit fours cake with the word *Willkommen* in iced chocolate sat on the table in front of me.

> *"I collect points at this hotel. I'm a club member,"* he said by way of explanation.

He began telling me about a woman who'd broken his heart years ago. A curvaceous middle-eastern woman who left him suddenly when he'd thought they were quite in love. He sounded nostalgic rather than bitter. Since that day he'd vowed never to fall in love again but to marry his business. And so, he booked a nice chubby whore to relieve him once a month.

Once he was finished with the storytelling, I pulled my dress up and bobbed up and down on his cock right there on the sofa. I made eye contact with the cake on the table wondering whether he was going to eat it once I'd left.

> *"Not too fast, or I'll cum,"* he said.

I ignored him, hoping to be let out of my two-hour minimum early but he wanted a massage. So, I filled out the rest of the time straddling his back and rubbing bits of him.

51

BOY was waiting to meet me afterwards. Waiting on the steps near Bahnhof Zoo. I kissed him hello.

"How was it?!" he said.

"I'm tired but happy. I'll tell you tomorrow over breakfast. Ah, breakfast, let's have it all! Scrambled eggs, salmon, buttered toast!"

You've been introduced, yes?!

BOY meet Mr Andrews. Mr Andrews meet **BOY. BOY** is the voice of reason. The grounding wire if you will. I'll let you two become acquainted.

I know it gets a bit heavy sometimes but what can I say. You're my muse! You are the reason I write. If you ever want me to stop messaging, all you need do is ask.

TEXT STOP TO OPT OUT OF MESSAGES

Mr Andrews: *"Really, what an honour?! Don't ever stop messaging me."*

Well now, I have your permission.

Chapter 15 – Dreckstück

Hans propositioned me:

> *"We're rebranding Rubenesque and we'd like Lady Lotte to be the face of it."*

Having endured one photoshoot with Hans, I didn't fancy repeating the experience again so soon. It should be mentioned that his shoots left you in arrears to the agency. You had to earn back the cost of the shoot or pay the difference before handing in your resignation. The more photos he took of me, the longer I'd be bound to them.

My initial experiences with Rubenesque were stressful. Albeit partly my own fault for not buying a better mobile phone. And partly for receiving texts in a badly spelt foreign language. And emojis that read as black rectangles. And an inbox that filled up so fast I'd have to delete the first half of the message to receive the second. Sometimes they'd get the client names mixed up or leave me waiting around for a room number. I'd be in a hotel foyer watching the revolving door go around and around, the concierge occasionally asking if I needed assistance. This dysfunction was very much the Rubenesque way. Did I really want to be the face of it?

"How are you rebranding?" I said.

*"Fresher, cooler, younger. Imagine a dating app full of hot girls that you **really** can take home with you."*

Girls didn't come home with Hans all that much, I was guessing.

"We're looking for something like this," he said and sent me a link to a site called Ingénue.

Ingénue was like one of those e-commerce lifestyle brands. The girls were all TV presenter hot with interests like DJ'ing or vegan food blogging. The minimally designed website was comprehensive and the girls got paid more than I did at Rubenesque.[12]

I emailed them straight away.

[12] It should be noted that the Rubenesque girls earnt €100 less per hour than the regular Salomé escorts.

Hi Ingénue. I love your website.

I'm Lotte, I'm from London. I work at another agency here in Berlin who just forwarded me your site because they're planning to rebrand in line with your look (oops!) probably shouldn't be telling you that — I'd like to work for you because you seem way cooler than them <3

Pix attached, lemme know!

xxx

To my surprise, they got back straight away. And that's when Artemis entered my field of vision.

I used to work in London. It's so great there!!! We'd love to have you. Let's have a call next week. What's your number!?

The excitement that I was about to move on to greater things was nipped in the bud. My interview with Artemis was deferred twelve times. I had given up all expectation of it occurring at all. Never would I be an *Ingénue*. At one point, waiting next to the phone feeling exasperated, she sent me a picture of her leg suspended in a cast.

Fuck! Sorry I didn't ring! I had a motorcycle accident two days ago and I totally forgot to tell you.

You alright?

Not too bad. The bike is gone though.

Artemis. It was quite an imposing name, not her real one of course.

Although I doubt that the 'real' name she gave was her actual name either. I had imagined her to be officious and take-no-prisoners whilst running her business empire but she wasn't like that at all. When we actually got talking, we spoke on the phone for an hour and a half. We took so many tangents that we quite forgot to discuss the matter at hand.

Her life as an escort started in London. She had been studying law and working for a smutty agency that specialised in fulfilling niche fantasies.

> *"I started my own company so that I would stop being messed around. Sometimes they would say are you free in one hour and I would say no and they would make me feel like I was being frigid or something. I want to be totally clear. We work for you and if you aren't available, or don't feel like it, that's totally ok."*

That was a comfort to hear. Rubenesque was quite the opposite; they didn't like to see me turn down a job, no matter the excuse.

> *"My favourite things are strap-ons and anal sex,"* she said. *"I love it, but that doesn't mean I feel like anal after a Mexican."*

> *"Do you get your girls to sign up to the register?"* I said.

"That's totally up to you. We're merely a conduit."[13]

The next day I received a questionnaire from Artemis and looked forward to taking my sweet time on it. I poured myself a hot coffee, pawed my German dictionary, and fetched my favourite dildo. It would require due care and attention.

Page one to five had a tick box list of activities:

Facesitting Activ
Facesitting Passiv
Fisting Aktiv
Fisting Passiv Vaginal
Fisting Passiv Anal
Dildo Aktiv (safe)
Dildo Passiv (safe)
Dildo Gegenseitig (safe)
Double Penetration (Penis und Dildo, safe) aktiv
Double Penetration (Penis und Dildo, safe) passiv
Erotische Ringkämpfe

Following this were some interview questions that read like a celebrity feature in Seventeen Magazine:

Describe your perfect date?

[13] The German Sex Worker's register is supposedly 'unbiased' and meant to combat trafficking. It's apparently purely tax related. I'm wary of it. Being on a register of certified prostitutes might mean nothing right now but wait until someone says they don't want a former sex worker teaching their kids. Incidentally, Berlin had a similar register in the much-romanticised Weimar period, introduced in fear of disintegrating morals. Only a fifth of people prostituting signed up and the percentage is about the same now.

What music do you listen to in your free time?
Do you have any pet peeves?
Pick three adjectives that describe yourself in a nutshell?

Artemis created a character spun together from my answers to these questions: Flora.

Becoming Flora was fun. The work wasn't abundant but it was addictive and you could make a lot in one evening. I'd find myself in German class craving the rush of an appointment, desperately listening for my burner-phone text tone. Earning money for Artemis played into my tragically trite sub-fantasies:

"Did I do a good job for you Madame?"

One time she sent me out to one of her old regulars and I felt especially spurred on to perform.

She did a good job vetting clients. My dates at Ingénue were casino owners, publishing tycoons and poor little rich boys with cocaine habits. People who'd tip and book you a taxi home. I don't know if there was a false sense of security in it, but for some reason I always felt safe with her. And she threw us a staff Christmas party.

"Last year we went bowling, it was zooooo much fun," she voice-messaged with her harsh German sibilance and howling vowels.

When the Christmas party came around, I did indeed feel like a debutante. It was a last-minute affair at a hotel in western Berlin, The Maîtresse. Echoing the high-class hooker experience, it was done out in lingerie colours: black, baby pink, and gold. A shiny

red Lamborghini sat outside with branded stickers all over it. The dinner was last-supper style at a long narrow table in the hotel's French/Asian fusion restaurant. Artemis and Paul were seated at the centre like royalty.

I had been booked for a date that evening so I was the last to arrive. It wasn't the grand entrance I'd dreamt of, rather more like me feeling awkward not knowing where to sit. I still couldn't speak German and was at least two stone more than anyone else.

Most of the girls were in jeans and jumpers but I was in my black wiggle dress and had stopped off in the foyer toilets to make my hair flicky.

"We could have sold tickets for this event," said the girl furthest away from me.

I would have bought one, I thought.

Artemis introduced me in a babbling of tipsy syllables:

"This is Flora, Charlotte, Lotte. She's kinky."

I seated myself next to a pretty blonde girl. She rather frightened me for her pragmatic austerity. Although baby-faced and blue-eyed, she only spoke of spreadsheets and percentages of repeat customers. One of Artemis' top earners. She lived alone with a grand piano. The piano and the lessons had been bought through her Ingénue pocket money, a fact she was proud of.

The woman opposite offered me a deep-fried sesame foie gras ball which I harpooned on a chopstick. Everyone looked

conspicuously gay and gossipy. My understanding was limited but it seemed like people were cross-referencing clients and comparing notes.

Artemis introduced Paul as her business partner and ex-boyfriend. He looked embarrassed when she went into a rant about how he never let her experiment with his arsehole when they'd been dating.

> *"Oh no, I remember now. There was this one time with my tongue and it wasn't so bad, was it?"* she said.

Paul took an instant shine to me. For some reason Pauls always do. It is my father's name, so maybe it's a Freudian thing. He had some family in London and seemed to think it was charmingly ad hoc that I'd moved to Germany. No one else seemed to think it was.

> *"It's not that exotic. If she'd wanted a real change she could have moved to Bali,"* one girl said.

As he sat down next to me, I could feel Artemis' eyes dart. The piqué in her interest spurred me on. Why I flirt with men to get closer to the women I fancy is beyond me. Artemis and I were closer in age and stature than any of the other girls. I felt we were alike and suspected that was why she took me on in the first place. I was indeed beguiled by her.

Paul introduced himself as Dr Paul.

> *"What kind of doctor?"* I said, knowing that higher education right into your mid-thirties was the German way.

> *"A Doctor of Economics. The true genius of this company is that what we're selling doesn't exist as a saleable commodity. Intimacy: no overhead but high retail value. We're selling a beautiful lie."*

I took offence at this. His view is concurrent with people who don't put their body on the line for their conviction.

> *"It's not a lie to me,"* I said, tempting Artemis' dangerous looks from the other side of the table. *"I don't want to pretend I'm in love with someone. It's not the kind of work I would like. I prefer the kink stuff. I am very uncomfortable with any notion of amorous pretence. Do it for whatever reason, but don't pretend to give a shit if you don't."*

> *"Have you ever paid for sex, personally?"*

He said yes, and that he found it unsatisfying.

I got up to go outside for a cigarette and Paul offered to join me. The front entrance was lit with Hollywood downlighting, illuminating the red carpet and the paving slabs beyond it. Away from the table we didn't really have anything to say. It wasn't as fun to flirt with Paul when Artemis wasn't watching.[14]

On our return, the Topic du Jour was:

A big part of sex work is listening to people's problems: Discuss.

[14] I know it seems like a terrible idea to flirt with your madam's ex-boyfriend but I don't think she held it against me long term.

The room divided into two motions:

> *"Hey mister, I'm not your therapist, ok?"* (That's really how Germans talk)

vs

> *"It's not about sex. We take time to listen to people who don't have anyone else to turn to."*

Collectively, this group of self-assured and beautiful women weren't about to condemn their own actions but there was a clear divide between those who saw it as a lifestyle and those who saw it as a clock-job. I longed to give my two pennies worth but didn't speak enough German.

Whilst I was in the company of fellow escorts, there was one matter that I wanted to clear up:

> *"Do men keep asking you to piss on them? So far like 50% of my Berliner dates have."*

The girl who'd offered me the foie gras canapé pulled a face and said:

> *"Certainly not! Men mostly want to take me for dinner, see what I look like naked and then have sex in missionary position."*

> *"You do have a pretty dirty write-up,"* another girl said.

> *"Oh, do I?"*

That was one of the quandaries with working abroad; I didn't really understand the nuances of what my profile was offering. I could translate the words but not the implication.

> *"What does Dreckstück mean?"* I said. Everyone went quiet. Directly it means 'piece of dirt', so I'd assumed it was like 'filthy'.

> *"It's not a nice word,"* someone eventually answered.[15]

As the group dwindled, we left the table and took a booth in the bar. Paul sidled in next to me.

In her eruptive style, Artemis reached breaking point. She turned to us and pointed her finger:

> *"I really think what needs to happen here is that you two need to go and make out in a corner or something. It's cool, totally cool. I'm completely fine with that sort of thing. You both are really nice people and obviously like each other. So, have fun!"*

Tears welled up in her eyes.

> *"I'm far more interested in **you** than Paul,"* I said.

[15] For me, being dirty has always been some kind of currency. Even if the other girls might be prettier than me, I am more likely to let you put it up my arse on a first date. My write up at Ingenue being case in point. It's led me to believe that beautiful people tend to be more vanilla. People treat them like princesses from a younger age and they imbibe a sense of self-worth from that. Whereas I glean my self-respect from a lack of preciousness where my body is concerned.

Which fell on deaf ears with Artemis but not Paul, who urgently excused himself from this drunken mess.

Artemis began to pour her heart out whilst scrolling down the cocktail menu with her finger. She stopped crying to order a *Double Penetration* cocktail and winked at the waiter.

> *"I see him every week and I can't run the company without him. It's all too much! And you're all so beautiful! And I'm just sat here,"* she said, crumpling her face into a new series of sobs.

> *"You're beautiful too!"* came the replies from hollow smiles.

> *"You're all so beautiful and nobody wants me! (Waaaaaah!)"*

I meant it when I said she was beautiful; she was far more captivating than anyone else at the table. Sinking into the booth, she looked down at my legs which were butted up against hers *(much to my delight)*.

> *"We're twins!"* she said, looking at our matching hold-up stockings. Like a switch had flicked, she picked up one of her phones and took a selfie of us.

Artemis excused herself, got up to go to the bathroom and walked into a curtain instead. We offered her a shoulder to hang off but she protested.

> *"No, no, I'm absolutely fine. I can walk a straight line when I'm drunk, even in heels. It's a skill I have!"*

She held her nose toward the ceiling and goose-stepped back and forth on a small imaginary line until she was happy that she'd demonstrated sobriety.

> *"I must go to sleep now,"* she said. *"I'll be sleeping next to my ex-boyfriend, in a beautiful hotel bed, wondering why it is we can't just kiss."*

She disappeared through the fringe curtain at the far end of the bar.

The next day I sent a text to Artemis' personal number to thank her for the lovely evening. She answered in a curt, businesslike manner. Perhaps it had been a little overfamiliar to message her, or perhaps she was feeling reticent about the loose-lipped conversation the night before. I smiled at her profile picture: a lady's ankles in maroon socks, feeding three black piglets. Her status read:

> *"Everything happens for a Riesling."*

///

Six months later, I had her undivided attention on the phone for the third time in my life. She was telling me about Munich:

> *"No wonder Hitler loved it so much; they're all fucking Nazis!"*

Secretly I wondered if Paul had lured her there. My low opinion of him plummeted even lower after I met up with another Ingénue girl:

"To be honest, he tries it with everyone. He even booked Julia a couple of times when we first started at the agency and tried to do it off the record so Artemis wouldn't catch on."

How many of the girls had he booked? I suppose the clean line of professionalism is muddy in the sex trade but isn't that all the more reason to adhere to it? I thought it was inappropriate and wondered what sad kick he got out of running his business like that.

Every Friday night, somewhere in the world, two or three girls would be shagging money straight into his wallet, and all he had to do was sit back with a glass of Liebfraumilch. This distaste I have for him relates not only to our initial meeting but a subsequent financial altercation. On May Day, when every street corner in Berlin is a party, I received a voice note from Artemis with these instructions:

Do not wire any money to the company account.

She asked me to bring her monthly cut in cash.

There was desperation in her voice. The United Kingdom being their chosen tax haven, I was able to look up the status of their company in my own language. Ingénue had been dissolved.

Upon my arrival at the cafe, I saw six angry girls with envelopes of cash.

Anaîs banged the table. She kept repeating the word:

"Organisation. Organisation. Organisation."

Artemis burst into tears and garbled that everyone was making out like she was some kind of pimp. Which of course she was. She stormed out of the café. I understood little of the seething German that erupted at the table. Then Artemis walked back in and cried some more.

"Paul is making me get trains to every German city and collect the money in person," she said, looking to me for sympathy.

"Is he being mean to you?" I said, dotingly.

"Yes. So mean!"

"Is this the end of Ingénue?"

"I think so."

Chapter 16 — P.O.V.

What happens when the phone stops ringing?

I was trying to earn money for my *'companionship'* as an escort in a country where I couldn't speak the language. Multilingual money disputes were just one of the teething troubles. Then business got slow.

It had been a while since I'd heard from Rubenesque. In curiosity, I clicked on their website and saw a new girl on their welcome banner: NEU KATARINA.

Katarina bore a striking resemblance to the wife of the village elder from an Asterix comic. A long-blonde, blue-eyed frau with oxen bone structure teetering on high-heels, making her look absurdly top heavy. Her nostrils flared like a prize filly but there was something strangely angelic about her fairness and serenity.

Gangrene began to spread: Was I not pretty enough? Was Katarina getting all my dates? Did I need to get fatter so I would be more Rubenesque?[16]

I signed up to an independent escort platform, but I struggled with the language. Then I started looking through Craigslist ads and found one that said *'Fluffer Girl Needed'* for porn-shoots. I exchanged emails with Sara at the casting agency who arranged an interview with one of their scouts at the American porn production company. I didn't get the name of the company but my contact was Theo.

Theo was described to me as: *"A sweetheart who has been working with us for a long time."*

I wasn't that interested in doing pornography but the advert looked like a stable option for a toe-dipper.

We arranged a meeting with Theo at *'a shoot location'*. I entered first and he closed the door behind him.

We climbed a dark stairwell. On the first floor were piles of shoes where people were meeting for prayer. We continued up two more flights. When Theo opened the door, the apartment was quiet and smelt neutral. Unnaturally neutral, neither freshly clean nor lived in. We went into the bedroom where I saw a spanking stool, two chairs, a bare mattress, and a Trojan condom wedged between a skirting board and the wood-chip wallpaper.

[16] It's okay to objectify yourself if there are takers but when there aren't it's embarrassing and deeply personal. One has to consider other options: Advertise your availability. Say yes to riskier acts. Or, put yourself on sale like a half price cheap cut of boiling brisket.

"ID?" Theo said.

"It's not on me."

He closed the bedroom door. I reached for my phone.

"I'm just texting my friend," I said, clutching for control.

"Take your time," he said and showed me to a folding chair in the middle of the room. He looked at me for way too long then said, *"Why do you want to work in the film industry?"*

"The film industry. Really?" I said and laughed.[17] *"What does the job entail?"*

Theo, now looking sweaty, said:

"Keeping the male talent focused between shots and ensuring morale is good on set."

I touched the sleeves of my dress; both were damp from the heavy downpour outside. My ballet pumps were giving off a musty odour.

"Is anyone else here?" I said.

"Yeah, some Eye-Tai camera boys sleeping off the jetlag."

[17] At no point in my contact with the casting agency had anyone said a word about the nature of the work. Everything was inferred almost to the point of shame.

Jetlag from Italy? It was so silent that I could hear the shoeless people two floors below getting down on their knees.

Half grunge and half redneck, Theo sported a close shave with a soul-patch. I'd say he was in his mid-thirties. He wore a white wife beater and plaid short-sleeve shirt, bolt jeans and a manchoker with a flame charm in the middle. I exacted the police description in my head, should the occasion arise that I needed to describe him.

"What kind of films do you make?" I said.

Perhaps I was breaching the rule to never talk about what was actually happening. He looked at me a little worried like I may have got the wrong end of the stick.

"Like do you have any specialist genre?" I added.

He was slow to respond, almost like he was stoned:

"Just kind of what's in right now. Gonzo and point-of-view stuff mostly, production-lite, churn it out."

I reflected on the comment and looked in every corner for a camera and at his shirt to see if his point of view was getting churned out too.[18] The conversation ground to a halt.

"You happy?" he said.

"Happy about what?"

[18] Spy-camera porn is a thing. Although I don't know what a hidden camera looks like and I'm ill-informed about porn, it does happen.

He asked again. Then he stood up and undid his belt.

"Oh, no one told me that would be part of the interview," I said.

He looked a bit pained when he said:

"Sara didn't tell you about the audition in the email? She should have. I'm sorry. That's completely misleading of her. I can assure you we have been running this company worldwide for a long time and are at the forefront of professional conduct. Would you like to continue?"

I proceeded with conflicted notions. Sara had stated there would be no physical interaction at interview stage. I started to sincerely doubt that Sara was a real person. Actually, my notions weren't conflicted I was just frightened.

What's another blow job to someone who's willingly given many? I told myself.

He came over to my chair, undid his zip and felt around in his boxers. Whilst I tried to relax into it, he kept reaching into his back pocket. My head was so close to him that his body went out of focus. I imagined a knife in his pocket and adjusted my stance, prepared to move fast if necessary. Neither of us seemed in to it. It was as though we were undertaking a mechanical task. He asked if he could put his hands on me and if he could touch my breasts, and then if I would take my dress off. I stopped.

"This is strange," I said. *"Someone should have told me about this, and besides is there really anybody else here? Or is it just us?"*

"You don't have to do anything you're not comfortable with," he said.

Dressless, it continued. I make it sound so passive. I was totally passive. He notified me of his imminent arrival. And the painful 5-minute act was done and dusted in a healthy bloom that ran out of my mouth and down my chest as I'd forgotten to close my mouth. Neither spit nor swallow, just a malfunction.

He passed me a towel and I wiped it away. My skin was goose pimpled and my hands shaky as I reclothed.

"How many times a day do you have to do that?" I said. *"Is this your job all the time?"*

"It's been up to 12 sometimes and it gets pretty hard, I mean physically speaking, towards the end of the day. But today it's only four. I do other things too, this and that. I'm getting more into production at the moment."

I was torn between wanting to bolt out of that bare bedsit into the rainy street as quickly as possible, or wondering if I should feel sorry for Theo, Theo the sex worker. Maybe the job was just a means to an end and in time he would progress through the ranks. Or maybe he would remain there until his dick grew dark and salty from exposure to leach-like mouths like mine.

When I got back to my flat, I locked the door from the inside. Jean Laurence was out and I was alone. It required an extra wiggle in the lock and a shove to shut it but was virtually impenetrable once closed. It seemed nonsensical that a person who sold their body by the hour should feel disconcerted by a

15-minute mid-morning detour. Yet even after a litre of wine, cocooned in my duvet, I was unable to let it go.

In a dream, I met Theo again. He greeted me on set and said:

"Looking forward to your first day?"

"Uh huh," I said brightly, just as I would on any first day at any job.

Chapter 17 – Identity Crisis

Theo messaged me from another email address and asked again for a copy of my ID. He didn't say anything about my interview or my prospective employment. It seemed an obvious truth, and still does, that Theo must have filmed our awkward encounter and would need my ID to upload it to any kind of website. I scrolled through '*casting couch*' porn categories looking for him, or me, or that apartment. I didn't find anything.

"I want a copy of your ID," I said.

He didn't reply.

"I want a copy of your fucking ID. Who are you?"

"BABY, IN SPAIN IBÉRICO IS MORE IMPORTANT THAN SEX!"

Chapter 18 – Velvet Dusk

I decided to go to Barcelona. For two months I stayed at a three-hundred-year-old farmhouse at the foot of a mountain. It was a commune shared between twenty artists from around the world. I was writing about sex work and conducting my business openly amongst the residents. Living transparently was jarring.

We lived side by side incongruously.

As I was in a new place, I fell back on my default sugar dating site.[19] Until I get to know a place I cling to familiarity. The fear of a fish-out-of-water.

That's when I met Velvet Dusk.

[19] Candy Girl operates internationally.

I told him I was staying with my aunt for the summer, a British expat with a charming villa, and that I was cooped up with my family and suffering ennui.

He offered to take me out to his favourite restaurant.

> *"Every city I go to, I like to find a place. That one place where they know your face and just how you like your coffee."*

Thus, making every city he goes to American.

> *"I'd love to be shown the sites,"* I replied.

On the day I met Velvet Dusk, I got up at 5am and caught the first bus. As I slipped past the mosaic of the Madonna and Child at the farmhouse gate, I genuflected. The sun was just coming up over the sleepy village.

Once in Barcelona, I walked the streets in my click-clacky shoes, ducking into shops and cafés and not really settling on one thing for too long. I'd planned to see an exhibition but got waylaid wandering. At one point I took a turn down a dead end and saw a number of women standing next to their front doors trussed up in neon lycra. Sheets hung out of the windows with slogans written on them: *'Putas Libertarias Ravel'*. A protest against the crackdown on street prostitution.[20] I knew that already but the sheets seemed more like an advert that they were

[20] Catalonia, where prostitution is semi-legal, has been dubbed The Brothel of Europe. A lot of customers come from France where it's fully illegal: https://www.theguardian.com/world/2006/jun/24/spain.gilestremlett

still open for business. With pimps hovering on each corner, I wasn't welcome there.

Around lunchtime I met Velvet Dusk for tapas. He drizzled a generous pool of olive oil over the charcuterie and talked evolutionary theory. He believed women had evolved their spider senses and used this to entrap men and that men were horny escape artists. He described this as a complex system by which the human race could continue to thrive. Since my date with this man, I've taken an immediate coolness to anyone who uses Darwinism to support their outlook. I didn't contest him other than to suggest that the future didn't look bright for me if youth was the best a girl could offer.

> *"No baby girl, you're doing great. You're white, you're Western, you come from a good family, and you're pretty. How's your relationship with your father by the way?"*

> *"What's that got to do with anything?"* I said.

He asked me back to his place. I was a bit apprehensive as I had the weight of 20 people relying on me not to get American Pyscho'd but I acquiesced because his apartment was in the Gothic quarter and I wanted to see what it looked like.

I kicked my shoes off and looked around.

His Memphis drawl and teddy boy look made him seem Elvisy. Elvis near the end not the beginning. One of the bedrooms was filled with XXXL Hawaiian shirts in every colour. It was the kind of Air B&B no one really lived in: a newly refurbished attic space with street noise, no proper furniture, an L-shaped leather sofa, and a palm tree.

He got his guitar down from the wall and sang *Wild Horses*. He really lost himself in it. His confidence was enviable. Turns out he had been a rockstar before he got into politics. I wondered if most politicians thought of themselves as rock'n'roll cowboys or if that was only in America.

"It's pretty much the same thing," he said. *"All noise and power-chords."*

Then he played the Eagles.
Then he played Springsteen.

He lit some Nag Champa and beckoned me to his bed. My libido lit up. The linen was high quality. I'd been sleeping in a spartan dormitory for a fortnight under a charming but thin quaker quilt. A real duvet was cloudlike by comparison. He spread my legs apart and said:

"Open up for me like a flower."

"No one's asked me that before," I said, trying not to laugh. He cut me off.

"I don't wanna know about any before. As far as I'm concerned when you're with me, there's only been me. Now be a good girl and lie back for Daddy."

I usually don't orgasm but there was something about Velvet Dusk's misguided sense of possession that pushed me over the edge. He held the back of my neck whilst he was fucking me. Just before he came, in a hurried outburst, he said:

"Tell me you love me."

"Ok. I love you?"

Looking out the window at the rooftops and washing lines, I made whimsy about the breezy continental way of life. He agreed. He loved it so much that he was returning to Europe within the year. His mother wanted to see Paris. They were renting a place there for a month in the autumn.

> *"I could put you up in an apartment over Montmartre Way. That way I can drop in on you any time!"* he said. *"Keep you as my courtesan."* He looked at me, misty, lost in his La Bohème.

It was an appealing offer. If it weren't for the caveat that I wouldn't be allowed to leave the house.

> *"What would I do all day?"* I said.

> *"Read. Sit on the balcony. Wait for me. Get dressed,"* he said, with sincerity.

Out of concern that Velvet Dusk and I might languor in the sheets for too long, I suggested we hit the streets for more tapas. We got dressed. He dragged wax through his hair with a tortoiseshell comb and sprayed himself with Oud.

After tapas he walked me to a taxi rank and pressed a deck of euros into my hand. I got out of the taxi once it turned the corner and hurried into the metro instead. Sprinting to the Santa Eulália stop, I made the last bus out of town. God knows how I figured out where to alight. The richness, the rushing and a lengthy coach journey made me queasy. As I turned off the B road down the dirt path, I threw up in a bush. I tried not to wake anyone up

as I slipped into the dormitory but the wooden doors creaked and the girl sleeping next to me stirred.

For our second date, I went straight to his apartment. He buzzed me in and I circled the five flights of stairs up to the loft. He was on the phone and gestured that there was beer in the fridge.

> *"Baby, I got you a gift,"* he said, placing his hands over my eyes.

He had texted me in the week asking for my top three perfumes, so this was not a surprise. I could only think of two so I included my mum's favourite, with a mind to regifting it. The plan backfired as he'd gotten my pseudonym engraved on the bottle. It was a gift set duo with a travel size version. Not wanting to waste it, I embraced smelling like my mother for a short while.

After we'd fucked a bit, we went out for dinner. Another rich meal swimming in olive oil. He splattered oil over the tablecloth in a vibrant attempt to dress the iberico. Sat opposite one another in this crowded wine cellar, Velvet Dusk suddenly became strangely formal.

> *"Lotte,"* he said, clearing his throat. *"We've gotten to know each other a bit and I like you and you like me. I want you to be mine, Baby Girl. I'll provide everything you need but it would have to be an exclusive arrangement."*

It's unclear whether he meant exclusivity for me or both of us. In line with his theories: fucking around was his Alpha-Masculine duty as was guarding the female to ensure paternity. He presented a scenario. He'd fly me to Maui every other month

and we'd go on European holidays too. But only if I could prove that I was being faithful to him.

My only reference points for Hawaii are Bette Midler and Moana. I couldn't imagine where I'd fit in. It's like we'd be in exactly the same apartment but someone would have photoshopped a Mai Tai in my hand and a hibiscus flower behind my ear.

What I didn't understand, and still don't, is: if fidelity was so important to him, why did he pick a girl he'd found on the internet and fucked within two hours of meeting?

> *"I don't think exclusivity is what I'm about just now,'* I said. *"Also, I have a life back at home. I can't just up and leave for booty calls in Hawaii as lovely as that sounds."*

His face went flat and the meal became awkward.

> *"You don't know what you want because no one's ever treated you right,"* he said.

> *"Is that your type?"* I snapped.

That last half hour of our interaction revealed the more genuine side of Brian, which was Velvet Dusk's real name. Unlucky in love, looking after his aging mother. Travelling place to place but not feeling like anywhere was home. He'd become jaded. I felt a bit sorry for him, Brian, The Slut Saviour. So many theories and so few real-life specimens to back them up.

Where was his evolutionary wondergirl?

In the street outside the restaurant, he gave me my pocket money and threw down his parting shot.

"Well, baby, I tell you one thing, you're the cheapest tourist attraction this town has to offer."

Clutching a wad of money in my fist on a busy street in Barcelona, I took in my surroundings and became very aware of myself.

YOU CAN TOUCH, YOU CAN PLAY,
IF YOU SAY I'M ALWAYS YOURS

Chapter 19 – Barbie

After Barcelona I went back to Berlin.

It all began to feel stagnant. The throb of three-day parties. The tech bros. The techno babes. Pills and poppers. The tidal comings and goings of people dressed top-to-toe in black sportswear, pulling suitcases over the cobbles as they landed in the city for the summer. I could see them from my window, fetishizing Nick Cave as they stroked their deliberately unwashed hair back from their face.

Wiling away an evening at a classic Berliner house party, everyone was lying on three mattresses looking at a projection of water moving across the ceiling to an ambient temperature of speed and ketamine. There were nods to 90s squat culture at

every turn: pallet furniture, a mural or two. Despite the aesthetic grit, the quality of life in Berlin is actually comfortable, or at least more so than London. The ceilings are high. The central heating is second to none. I didn't feel scared walking home at night. It's a pleasant city to live in once you get settled.

Everyone at the party was an expat. We were all in a precarious employment and none of us could speak German well.

Moving through the rooms, I heard a tidbit from a self-assured woman who I knew to be a sugar baby:

"He bought me as a birthday present to himself," she said.

I walked away. Sometimes the babies are as bad as the daddies.

Then a girl called Barbie came up to me in the kitchen.

"I've heard about you. You're in the sex industry," she said, and I was a little taken aback.

"I wouldn't say I was."

Barbie began describing her life in Berlin. She wasn't so sure about anything. She couldn't keep a job and was struggling to learn German. That would describe about 90% of the people at the party but there was something intense about Barbie in the way she gave you the full run down. For someone so open she wasn't the sort you found yourself trusting, like she was always assessing the situation for what she could get out of it. She rolled me a cigarette and told me she had just joined Candy Girl. Surprise, surprise.

"I was kind of broke last month and then this tech dude dropped me two grand. Cleared my rent debts like that," she said and clicked her fingers.

"Sounds great," I said. *"Was it a one off?"*

"I don't want it to be. I want to do it more. Will you help me?"

"No."

"Ok, well, let's have a picnic next week. You can pick me up from the café at five on Tuesday."

In London this invitation would have been overfamiliar but in Berlin everyone is lonely and grateful for contact.

We met at the park.

"I went on a sugar date after the party last week," she said.

"Straight there?" I said.

"No, I went to a club first and then met up with this guy later. I'd been on G[21]. I was shattered."

"Did you fuck him?"

[21] GHB/GBL – the date rape drug. It's the one substance that night clubs in Berlin ask you not to bring in. It's easy to overdose on it. It makes you mad horny and buttery at the edges.

*"Yeah, we had sex. He didn't pay me yet or anything. I just passed out in his bed because I was so tired! Anyway, that was just a practice run. I'm going to be more serious about this now. What can **you** tell me about escorting in Germany?"*

"Umm, I know that I find this sort of fun and totally addictive, but I don't like to rely on it."

"No, not about how you feel. Like facts. Places, rates."

"Nothing! I don't want to tell you anything. I don't want to be responsible for your actions in any way."

A fortnight later, I bumped into her at an 'open air' party on a Sunday afternoon. I lived around the corner, so I invited her for a nightcap at mine, something I soon regretted. She loved the apartment. So did I. It's probably the nicest room I've ever rented. My flatmate (also an expat) was lovely too.

Barbie asked if she could use the apartment for a sexy photoshoot for her Candy Girl profile.

"Come on! It'll be fun!"

I wasn't keen but she wouldn't drop it, so eventually I invited her over.

She offered to take some of me too.

"I'd die of embarrassment," I said.

"Just a couple. What's your favourite underwear? Do it!"

I put something on. The mutual nudity made it less awkward, but the pictures were terrible.

"I think it's great how you're so comfortable with yourself," she said, only adding to my discomfort.

Afterwards we lay on my bed scrolling through the internet.

Is this what's happening now? I thought. *We're both sat here looking for pseudo-Johns together?*

"Look at this guy. Slick, a bit up himself. Dubai secondary location?" Barbie said.

"Eww, no way. He says he likes a lady to look after herself. I hate that!"

I'd not signed into Candy Girl since Barcelona and my body groaned with the familiarity of it.

"How about this one? Seeking my princess, lol!" Barbie said.

"Are you a princess, Barbie? What do you want from this knight in shining armour? An allowance? Gifts? Grab your passport and discover the unknown!"

"Naah, I want CA$$$H! But it's finding and extracting it from them. I mean, they know what's happening as much as we do. Why do they make it so hard?"

"Yeah, it's fucking tedious, isn't it? It's not like I'm withholding my side of the bargain," I said shoving my tits together with my hands.

After our playdate, Barbie and I started texting. About this guy or that guy. She'd gotten totally absorbed in it and I felt strangely responsible for her. One day she turned up at my front door.

"My friend is annoyed at me and I quit the café and everything is all over the place. But it's ok. I've made another friend instead, who's crazy like you. I'll introduce you to her."

"I'm not crazy, Barbie."

"We both are. Just a couple of crazy girls, living hard."

"I'm not crazy."

Then I started getting annoyed and said, *"Hey, listen, I'm leaving Berlin."* I didn't actually mean to tell her but I thought it might make her go away.

"Oh really, who's taking your room?"

"You're not having my room."

"Why?"

"Someone else already has."

She was still in my doorway, so I felt compelled to invite her in. I knew once I had, she wouldn't leave.

> *"How about I just charge my phone and you can get on with what you need to do?"* she said.

> *"No, I want to be alone in my apartment. Alone, by myself. I'm working later and I need to be in my own head for an hour or two!"*

I finally got Barbie out the door and closed it, feeling drained. I sank down to the floor wondering if we were alike.

That same week my estranged father decided he was coming to Berlin. I hadn't seen him for a long time. He invited me out for dinner, with his obnoxious girlfriend, and I accepted.

I'd never really liked my dad's girlfriend.

She was wearing a grotesque baby pink t-shirt with diamantés, white jeans and rose gold kitten heels and was sat in the enclave of my father's arm. He didn't say much; nowadays his girlfriend talks for him. After a brief and formal meal, we parted ways.

Whilst my father was still knocking about in Germany, I met up with a fellow escort to moan about the John who'd cancelled. She told me a sob story about her upbringing. Her father had disappeared and left their mother to bring up their kids with no money. She enjoyed the financial independence of escorting because she didn't like how the rug had been pulled from under her back then.

"Snap," I said.[22]

Drunk and riled by her story, I decided to pay a visit to my father's hotel. I dragged them to a bar in an outdoor gypsy courtyard, which I was rather fond of, with festoon lighting and tiny birds everywhere.

I hadn't intended what happened to happen, but it did.

My father, a man of few words, was unusually vocal. Orating about his loft extension, I started to get lairy. He alluded to his house being close to the golf course, a plus for him as a keen player. I asked the table next door for a cigarette and whilst I was smoking, he asked:

"So how has work been in Germany?"

I was thinking, wow, the man knew so little about me and hadn't actually asked me anything personal up until this point.

He had no idea how my week had been.

He had no idea how my life had been.

He had no idea about anything which meant anything to me.

Without thinking it through, the hurt teenage temper trap in me replied:

"Workwise, I fuck old guys like you for money."

[22] Well, something like that. My dad fucked off and tried to pull the plug too. But my mum eventually sued his ass.

My father and his girlfriend kept on talking as though I hadn't said it. Almost like they decided not to hear it.

So, I said it again:

> "Sorry, Dad, I don't think you heard me. I fuck old men for money."

His girlfriend chimed in:

> "Oh, don't pretend like you have to do that. Why don't you move back to the UK and get a real job?"

After a moment of silence, like just before a baby is about to cry, I started shouting:

> "You don't get to come here and tell me about the hardships of your loft conversion! Why would I care about that when you left us with nothing?"

Which was a bit of a leap but it's what I said. If I'd been sober, I'd have said something more cutting like:

> "There's enough skeletons in your attic already. Do you think it's wise to be building a new one?"

My father, true to form, said absolutely nothing.

> "Nothing!" said the girlfriend with her feathers puffed out. "He left you with nothing! Did he? Your mother…"

She didn't get to the end of the sentence because I cut her off by throwing a glass.

"This is your fucked-up family, not mine," she said to my father and stormed off.

My gurgling sob-rant became inaudible at this stage. It oscillated between *"You fucked up my sister!"* and *"I don't care about your loft conversion"* like I was stuck on some kind of middle-class tape loop.

Then I stomped off with the wine bottle in hand. I sobbed through the night-time boulevards of central Berlin until I was exhausted. Dragging my feet across Alexanderplatz, howling and leaving crazy voice notes to **BOY** *(which on replaying them in the morning were a shockingly candid rendition of what everyone else must have heard).*

A homeless man collecting bottles approached me.

With rosy cheeks and a knitted hat, he looked like an extra in the cast of Oliver Twist *(I do realise how bad this sounds).* I sat down next to him. He got a half drunk Sterny[23] out of his bag and handed it to me.

> *"Was ist los?"* he cooed like he was putting a baby to sleep.

> *"Mein Vater ist kaput,"* I replied.

Sobbing into the man's jumper and braces, I said it a couple more times. Then we started kissing and I remember him tasting of beer.

[23] Berlin's 70-cent beer.

When I woke up the next morning, to my disappointment I recalled the night before perfectly. OR maybe it's better to know what happened.

I charged up my phone and expected to see a hoard of dreadful messages from concerned parties, but I saw nothing. Not a trace of the evening gone by. The only notification was from my bank. My dad had dropped a grand into my account.

We've not spoken since.[24]

[24] Well, we've exchanged perfunctory greetings like 'Happy Christmas'. God forbid he ever address what happened, which he won't, because he's a coward.

POLITE NOTICE: THE RESTROOMS ARE FOR PATRONS ONLY.

Chapter 20 – Full Service

When I moved back to the UK, my loose plan was to get back to my window dressing career. A plan that somewhat went to seed. Then one day out of the blue I got a text.

> *"Hey bbz! There's this John I'm just too busy to see. He's UK based. Shall I pass you his deets?"*

It was Barbie.

I couldn't imagine someone who was attracted to Barbie finding me remotely desirable. But hey!

> *"Hmm, alright then, sure. I'll take his contact and give him a text."*

A week later, a man I didn't know sent a text asking if I provided a 'full service'. He used my real name and the text came to my real phone. I hit the roof and told him absolutely not, that I didn't know what he was talking about and never to contact me again.

Then I rounded on Barbie:

> *"Did you give my real number and real name to a man looking for a whore! What the actual fuck?"*

> *"Only your first name. I didn't know what your working name was."*

> *"And you didn't think to ask? I mean, do you use your real name?"*

> *"No, of course not."*

> *"Then where the hell do you get off giving mine out?"*

That was the last time we were in contact.

HOW ABOUTS A PET COCKROACH INSTEAD?

Chapter 21 – Memory Foam

This one time, Mr Andrews coined his life with a story about a boiler. It made a persistent rattle so one day he picked up a copy of *Private Eye*, stuffed it behind a pipe and the rattle stopped. And that's the wedge which holds his life together.

My mattress is his boiler.
Predictably, it's bed-shaped.

> *"Fucking impossible! You have the worst fucking bed in the whole fucking world."*

BOY says one day as he walks out the front door with a limp on his right side.[25]

[25] The limp pre-dated the bed.

"MOve Fast ^ Break things, you Cunt!" I shout after him.

My back hurts too. They really are the worst mattresses in the world. The landlord, who lives three doors down and can't look me in the eye, has four CCTV cameras on his front patio. He clearly knows the value of material goods. However, he furnishes each of the seven rooms in our 5-bedroom house with the most rudimentary sleeping apparatus. These have been passed down without scrutiny through tenant upon tenant who all writhed in pain like figurines on Rodin's *Gates of Hell*. However, we put up with it because no one pays £385 per month in London; it's **unheard** of.

Steven[26] has fleas again so the mattress is also ridden. Every house I've ever rented has had an infestation of one sort or other. At least it's not cockroaches. Although somehow, they bother me less because I associate them with exotic climates. Pantry moths were the worst. In my first house we were cooking in the kitchen and Lizzy screamed, *"There's a maggot in my pasta!"* We all looked up at the ceiling writhing with larvae.

Adults deserve memory foam.

Upon perusing my options, it becomes clear that I won't be buying a new one.

> **Option 1**: There's loads of brands and they nearly all have 100-day free trials. Could I coast from start-up to start-up taking 100 days of each like some kind of 00s *Arabian Nights*?

[26] Our adopted house cat and 80s popstar reincarnate.

Option 2: Is it grim to go second hand?

Growing up, my bed was bought off a sick lady by my grandmother who had waited for her to die in it before collection.

An ad pops up on Gumtree and it's only 30 seconds old. Can't get newer than that.

Super King memory foam mattress, 6 months old, from guest bedroom. Must go this week. SE19. £50.

Super King. That's more of a status than a size! I message the seller (Harry) and say I'll pick it up within the hour.

His house is lovely — Georgian, cul-de-sac, terraced with steps up to the front door. It's blandly decorated with mediocre occidental accents. Harry and his partner, who I learn is called Viktoria, have no interest in The World of Interiors. But who am I to cast stones?

"So how is this going to work?" he says.

Casual transactional meets are rather my area. Harry is clean-shaven and wearing high quality, navy blue, jersey jogging pants and a Carhartt t-shirt. He's Australian and works in finance. I reach into my bag and present my ratchet straps. He looks at me regrettably like I'm his angel of death.

The mattress is in the guest room, as stated. It's enormous. I've never seen a Super King size bed out of the context of a hotel room and it's more than a handful.

"Do you think you might be able to give me a hand with getting this downstairs?" I say. *"I thought we could try rolling the mattress, pinning it down and then maybe you could hold it steadfast whilst I get the straps round it?"*

I'm not sure what's going to happen next but he agrees. It's much less pliable than I had imagined. It requires use of all limbs and body weight to pin the beast against itself and causes us both to break into a light sweat. Our first attempt is more of a warm-up. I remove my jumper and we position ourselves for a second turn. Playing twister with this mattress breaks every known parameter of personal space between strangers. We pin it down. His thighs are straddling the roll and my breasts are sandwiched over his forearm, trying to fasten the straps.

The ratchet straps are effective; we are both impressed.

"If I ever need to dispose of a body, I'll know who to call," he says.[27]

The mattress needs to descend three flights of stairs but at least we are working **with** gravity. Through a method of clearing obstacles such as plugs and trainers, we get the mattress through the front door. It's a tandem effort of pulling and kicking and takes about 20 minutes, after which we are both spent.

"What now?" he says. *"Is someone coming to pick you up in a van or something?"*

"I'm gonna call a cab," I say. He's looks at me like the nightmare will never end. It begins to rain.

[27] That's it, Harry. This is kind of fun isn't it!?

"Don't worry, you have no idea how much can fit in the back of a cab until you try. Trust me."

The first two taxis turn me down but they have better offers due to the unexpected storm. Harry's beginning to lose faith and so am I, but, I **really, really, really** need this to work because I don't have means to get it back otherwise. The third taxi driver demonstrates how much the mattress will not fit. In demonstrating, it transpires that the mattress does actually fit, when I shove it in on the diagonal with all the seats down. *Told you so.*

"Adieu, dear Harry. If it doesn't work out with Viktoria, I could spend your money better than she does!"

As we pull up to my house, I can't help but notice the slumlord's wife twitching the curtain to see what's in the boot. One corner of it dips into the gutter and picks up some debris as it explodes out of the car. She looks suspicious but I don't care because this monolith is home, and it's mine.

There are still two problems outstanding.

Problem 1: *There isn't room for two mattresses and I'm not allowed to chuck the first, even though it's hopping with fleas.*

Problem 2: *It's ten inches too large for the bed base on every side.*

Problems need solutions and like everyone on the cusp of semi-employment in the creative industries, I'm fluent in solution-based thinking.

Problem 1: I grab Luca from a Netflix coma; he is conveniently between jobs too. Having already done this once, we manage to neatly gaffer the mattress into a sausage with relative ease and grace. We keep the fleas at bay by incarcerating them in pallet wrap. Then we work against gravity to find it a home under the rafters.

Problem 2: We address the overhang with boxes and books. Luckily, the girthier books also happen to make me look well-read (even though I haven't read most of them). The mattress curls up at the corners like a piece of toast but The Count of Montecristo's under my pillow and it looks relatively bohemian.

I have bought into the dream and it is every inch as great as the poster. Even when I starfish, I can't touch the sides. Imagine the endless fun that's to be had. I text **BOY** *"I've got a surprise!"* and wait for him to get back, feeling a spontaneous heroine, irresistible for my unpredictable purchasing power.

"It takes up every square inch of space that you have and is ill-considered. Why didn't you wait and get one that fits?"

It's not just him who says it. Everyone comments that it doesn't fit in my room. Still, once people sit down on it, they rarely leave. It's a thing of beauty amongst squalor. If I could apply this bloody-mindedness to every aspect of my life, I'd be getting somewhere but for now I sleep on clouds.

Chapter 22 – Levi

I was on the sugar-sites again. It felt like a far cry from the clarity of escorting.

I was late for my first date because I couldn't find a toilet to get changed in.

> *"Work's keeping me (crying cat emoji) be with you soon,"* I typed, trying the loo in Pret á Manger and finding it already occupied.

> *"Don't work too hard or you'll melt those feminine features,"* my date replied.

His message instantly conjured images of lard-slathered bodies swimming the English Channel.

Mr Andrews: *He said what!?!*
Mr Andrews: *Sorry for radio silence, been stacked. Send date news, particularly if sordid.*

When I arrived at the hotel, it turned out the bar was closed for a magazine launch party.

> *"Let's stay a bit,"* my date said and we gate crashed the party.

With it being so near to work and thronging with start-up types, I felt certain I'd bump into someone I knew. I couldn't hear him well through the pervasive house music so I suggested we try somewhere quieter. He offered dinner at a Mediterranean café somewhere near Spitalfields.

Once we were settled, my date, Levi, described himself to me.[28]

> *"My book is my Everest."*

He was taking a three-year hiatus to complete his manuscript entitled *'Gender Politics Now'*.

> *"I'm an Anglophile. I moved to London from Tel Aviv to be with a beautiful English woman who broke my heart."*

> *"Excuse me, I just need to send a text,"* I said.

[28] Levi was a sugar date from Candy Girl but I didn't try to make a bargain with him. I went on the date because I was curious about his book.

"Who are you texting?"

"I'm checking in with a friend who worries about me."
(Actually, I texted **BOY**)

"Sure. Ok. Let's take a selfie for your friend and then she'll see what kind of guy you're with."

We leant in together and he took the photo on my phone with his arm around me.

Of all the dates I've ever been on, no one has ever volunteered an image. But Levi wasn't covert about his operations. On the contrary, being a Sugar Daddy was an extension of his thesis.

Not a dirty secret but a cultural certainty.

"What are you looking for?" he said.

"Fun."

"Come on, baby, everyone's after something."

"I really wanted to hear about your book."

He didn't buy it, even though it was by and large the truth. He illustrated a romantic dreamscape to me: his ideal situation would be to date one beautiful woman who would be his all. Whom he could take to tropical places and lavish with gifts.

"When a man's in love with a woman, he wants to give her everything."

*And when I'm in love with someone, I **do** give them everything but it doesn't always fit in a suitcase*, I thought, my mind flashing back to a painting I'd made for my first love out of my menstrual blood.

He outlined the book for me.

> *"We're seeing unsuccessful marriages, no babies and less sex! Guys, what's happening? There's been all this talk of dismantling gender boundaries and sexual orientation. But we still need strong men and strong women; it's the foundations of our civilisation. I'm writing this book for the ladies out there because they're the ones being sold short."*

Hang on a second, I've been here before, I thought. *It's like Velvet Dusk all over again.*

> *"Can I persuade you back to mine?"* he said.

We walked to Levi's flat, an industrial studio loft. He lit a joint and offered me a drink, but didn't give me much time to sip it before he was kissing my neck. There was something demonstrative about Levi — and assertive. For every inch of *easy going* there was a trace of agitation. He asked to *see* me and backed away to look at my full silhouette. The art of tease demands that you feel comfortable offering yourself. I flounder at such confrontations.

It didn't take long before his body was on top of mine on the sofa.

> *"Do you have a condom?"* I said.

"I got tested just this week, baby, so it's fine."

"Have you got the results yet?"

"Hon, it's only a problem if you think you have something. I'm fine."

So be it — he fucked me and it was great. His cock was really hard and he came down my inner thigh. My favourite kind of stranger sex.

I got dressed quickly and made my excuses.

"How do I know I'll see you again?" he said.

"Why don't you lend me a book, then I'll have to give it back to you."

"Ok, but you better! Here, take this one."

He pulled out *Five Love Languages*. I was duly disappointed. Of all the books on the shelves, and there were hundreds, he chose this putrid piece of pop psychology. Besides, I'd already taken an online personality quiz to see where my love language was at. I apparently need affirmation. Affirmative words telling me I'm doing OK all the bloody time.

"This is for you to figure out what you need from a man." I left, fully intending never to see him again.

Chapter 23 – Femcel

I had been booked on a six-week window dressing job in Saudi Arabia, but the job got snapped away as quickly as it landed in my lap. So I went back on Candy Girl, in a much more decisive manner.

As I was looking for cash to bridge me over, I probably should have branched out onto some other platforms. I looked around for escort work but struggled to get a breadth of it, UK side. Truth be told, I was scared of the British options because they all looked seedier than Berlin. I was on home turf and clinging to that stigma-busting get-out-clause that sugar dating isn't really prostitution. Say I should bump into someone on my evenings about town:

"Oh! Hello teacher-from-school. What? This man I'm on a date with? He looked so much younger in the profile pictures! I promise you."

Within ten minutes of being online, Levi messaged my phone.

"Hey beautiful. You're back on Candy Girl, but I thought you were too busy to see me again? What's that about?"

"I'm looking for someone to pay my rent, and you're lovely but I need something quick and simple," I replied, and instantly regretted it.

"We can sort something out. You don't have to be doing that kind of thing."

In retrospect, it was a terrible idea. However, somewhere between *'a bird in the hand'* and *'better the devil you know'* cajoled me into thinking I should go on another date with him, this time to pay my rent.

He liked to have what he called a sex sandwich: shag energetically before dinner, eat leisurely to refuel and have a slower, sleepy fuck whilst digesting. It's a pretty good combination, Mediterranean even. He asked me to bring a bottle of wine, under the guise we'd order take-out. When I arrived, he'd changed his mind and wanted to go out instead.

He beckoned me to sit on his sofa then perched himself next to me with his hands on his knees.

"I'll level with you," he began.

He told me that:

He'd met prostitutes and I'm not one. That I'm clearly from a *well-to-do* background, so someone responsible for me must have dropped the ball at some point. If he had been my father, that never would have happened. That he could only assume it was a naïve foray into the unknown and he was disappointed but it was excusable just this once.

There was nothing clean-cut about this exchange at all!

And it was entirely my fault because Levi, if anything, was consistent.

He declared that the money he was offering was a lifeline. It came under the proviso that I take it **very, very** seriously and sort myself out. He cupped his hand under my chin and kissed me.

He had a few questions before coughing up:

>*"Have you ever cohabited with a man before?"*

>*"Do you have a boyfriend?"*

>*"What is your relationship with your father?"*

At some point during his lecture, I started wrestling with my own internal angst:

>*Give it a rest, Levi. I am a woman nearing my thirtieth year and for the record I wouldn't let my own father talk to me like you are. But the fact I'm sat here enduring this lecture*

is at my own detriment. No one made me go on a second date with you. You raise a good point; I don't have to be doing things like this. Should I be fucking people I disrespect for fun? If the shoe was on the other foot and I was a man who enjoyed banging women I didn't have an ounce of respect for, that would sound to me shady at the least. Or maybe it's ok if you know that's what you like to do and acknowledge it.[29]

Levi didn't have cash with him even though we'd arranged this five days in advance. I gave him my bank details and in doing so I disclosed my real name. He used it again and again, pointedly, as though he was pounding my ass with it. Levi was controlling but you can't control someone who doesn't give a fuck about you and I think deep down he sensed this.

We went to one of those late-night Vietnamese restaurants. As we sat down, he ordered me a beer. I'd drunk the best part of a bottle of wine before I arrived so a beer on top of that seemed like a bad idea. A plethora of seafood dishes landed on the table: mussels, prawns and seabass. He sat back, looking cocksure, then put his hand on my knee.

Surveying the room, he commented on 'these girls denying their femininity' and shook his head in disapproval. He called it 'pop androgyny' and said it had been the fashion for too long.

[29] It really does worry me because I have this deep-seated concern that I'm the inverse of an incel. Elliot Rodger was an active incel personality. He wrote a manifesto called *My Twisted World* which detailed everything he found wrong with society and then he murdered six people before ultimately killing himself. I worry sometimes that I'm giving you a rendition of my rather more Saturnalian universe. I guess I'd have called it something else. *My Twisted World – all tied up in cherry knots.*

111

"Not like you, baby (he winked). *You know you get guys who are ass guys, guys who are into tits. See, I'm a face guy. I just love a beautiful woman's smile."* Then he stroked my face. Which made me bristle.

The laws of attraction, to Levi, hinged on opposites. Homosexuals **do** exist but with their own binaries. That's why there are dykes and lipstick lesbians. There's always the man and the woman in every relationship.

"I've been out with women," I said, knowing it was going to rattle his cage.

"No you haven't, honey. You're just confused."

"No really, I have. I was head over heels for my ex-girlfriend and she was far from 'dykey'. In fact she was a total tits'n'ass blonde bombshell." (she was)

He put it down to sexual experimentation, another of my naïve forays.

No, you're the experiment darling, I thought.

After dinner, we went back to his house for the inevitable second half of the sandwich.

As I lay back on his futon, post-coitally, I suddenly felt violently sick. A hot nauseous flush took over my entire body. I'm going to blame the seafood. He was rolling a joint to smoke in bed, clearly planning to trap me there like a beetle on its back. As he lit up, I realised that unless I made a run for it, I was going to

shit myself too. The last place in the world I wanted to do that was his apartment. His bathroom didn't even have a lock.

I pulled my clothes on, not bothering to stop for my knickers, and made my way down the ladder. Trying to be polite but concentrating too hard on my gag reflex to make much sense.

"If you leave now, I'll never see you again," he said. I shrugged.

"I'm putting my cards on the table but if you're not ready to say yes to a relationship, then that's on you."

I replied:

"Goodbye. Thank you. Sorry."

Chapter 24 – Nostalgia

I went back to Berlin to visit a friend but it wasn't the same.

Mr Andrews, a postcard from Berlin!

In which I am a cunt and so is everybody else.

I hope you're enjoying what's left of the season. Are you on the Suffolk coast in the sheeting rain?

As a child, I always wondered why adults chose such enduring places to make holiday. For me, I longed to build sandcastles on the sunny, sandy beach like on an Easy Jet poster. Now I realise that it's all part of British cultural conditioning. I've adjusted to love the seaside in all its brisk and dismal splendour accordingly.

It's weird being back in Berlin.

Lotte

AUNTIE LULU IS SCARED
oF SHARKS!

Chapter 25 – Uncle Al

I headed back to London and almost as soon as I landed, I was planning my next trip out of there. Then lockdown happened.

My six flatmates and I were trapped in that flea-ridden house. It was both a blessing and a curse. We became a superstitious group bound to rituals, horoscopes and old wives' tales. I went to the supermarket with no knickers on to get my kicks and climbed out the window onto the roof to sunbathe. We drank cheap fizz from the bottle in pink bubble baths with an abundance of towels that never dried and hung off every door frame. We mulled over our anxieties until we were sick of the sound of them. Sick of ourselves and each other.

We were a feral family.

My civvy-job didn't exist. Instead of work, I experimented with not eating, laxatives, drugs and midnight walks through dark parks. I was existential, broke, horny and writing it all down. During this time, I went back on Candy Girl. It felt like a good place to aim my exhaust fumes. The only people online were so lonely they resorted to breaking rules or believed themselves above them. I decided to go on some dates, but only to see people who lived alone. A compromise to appease my guilty conscience.

That's when I started chatting with Uncle Al. His talk was dirty and I was in the mood for it. He wanted me to play a little game that I was his young masseuse, Epstein-style. He procured me for himself and his wife and planned to seduce me into performing sexual favours by throwing money at my feet.

Now, I'm no teenage girl but I have this perma-innocence about me. It plagues me in every area of my life but has been quite lucrative in the sex trade. School girl, step-daughter, virgin, I've played them all and I feel no remorse about it. Why shouldn't I make some money out of a personality trait that holds me back in so many other areas?

Enticed by Uncle Al's creative flair, I slipped into the back of a taxi. The driver wore gloves, a mask and sunshades. There was a sheet of plastic stapled between the front and back seats.

When I got to the front door of this luxury apartment building, concierge told me I wasn't allowed to come in. But the man let me through the sliding door any way.

> *"Oh yeah, I should have warned you about him,"* Uncle Al said as he opened the door.

His apartment was on the 34th floor of a glass building overlooking the Thames. I hadn't seen so much space in a long while. He ushered me into a hotel-like spare bedroom with a massage bench. I wasn't sure how much his wife Lulu knew about our arrangement, so I spent 45 minutes trying to pretend I was a real massage therapist using techniques I'd learnt from YouTube. We made small talk about how hard the water is in London and she self-consciously covered her nipples as I rolled her onto her front.

Uncle Al was in the other room playing remote poker.

> *"We're gonna see that dumb blonde bitch get roasted on CNN tonight!"* I heard him shout.

He was a tanned Wall Street type with slicked back hair. In a cigar-chuffing way he was affable but he bulldozed his wife's delicate nature.

When his turn came around, he wasn't so interested in my massage skills. He just wanted to bend me over and fuck me from behind with my face pressed against the glass. The London skyline looked incredible from that height.

He didn't want to use a condom either. They never want to use protection.

[30/04/2020, 19:22:10]

Lotte: *And you're no different, might I remind you.*

If the pandemic has taught us anything, it's that money doesn't make you immune to a virus. But it certainly can help — if

you're Uncle Al and Auntie Lulu, who had wrangled antibody tests months before they were commercially available.

"Ok. As long as you promise you're clean."[30]

Mr Andrews: *I thought I was special.*
Lotte: *Did you now.*

Clean of COVID or STDs?

Whilst Uncle Al was fucking me, my coconut-oiled hands slipped on the glass. The streaks must have been visible the next morning but I suppose the housekeeper would have cleaned that up.

Afterwards, we all sat in front of the oversized flatscreen television and watched a documentary about shark bites. It turns out they had a holiday home in the Seychelles where they went diving. I learnt that sharks are Lulu's greatest fear. Then I realised I was so drunk that I couldn't stand, so Uncle Al called me a taxi.

When I woke up, I discovered I'd left my make-up bag there. Uncle Al wasn't answering my messages about it getting it back.

I'll be damned if I'm spending that money restocking my cosmetics. It should only be used for subverting the system not making myself prettier within it, I thought.

[30] Like all insecure sluts, I try to make up for my shortcomings by offering a full service. Sex work is a service industry job and it's hard to leave that 'customer is always right' mindset behind. I blame society's obsession with telling little girls to shut up and smile. I'm getting better at drawing boundaries but sometimes it still feels like a struggle.

[05/05/2020, 16:42:40]

Lotte: *Where are you? How is it for you? Have you blocked me or something? Or, are you just less fun now that you're locked indoors?*

< Insert meme about Shakespeare writing King Lear during quarantine>

Hope it's going well.

Lotte
x

NON, JE NE REGRETTE RIEN.

Chapter 26 – Suburban Bliss

Lockdown kept going. People were scared and bored in equal measure.

I'd become amorphous.

It occurred to me that the holes in my short-term memory were increasing. I'd blacked out most nights that week. I couldn't remember ordering late-night takeaway cookie dough but the debris lay around my room amongst empty glasses with red stains at the bottom. I spent my time trying to join up dots. **BOY** tried to stage a light intervention. His ex is an alcoholic and apparently my behaviour matches up. Functioning alcoholic. The tendency to escalate into drunken misinformed rants. Playing devil's advocate. Whispering *"rape me"* whilst passing out and not knowing what happens next.

[18/06/2020, 17:28:00]

Mr Andrews: *I'm back!*

Lotte: *Just in time. I'm about to go on a massive bender.*

BOY, Johnny and I hopped in a car and drove to a suburban house with no furniture but a great sound system. We had a boot full of beer and a load of baggies. We danced around naked listening to music and watching films projected onto the wall. There was something delightfully childlike about the way we retreated from conversation and into our bodies. After a plethora of substances, **BOY** fucked my face so hard I felt like I was floating outside my body. For a moment there was nothing but convulsion, suffocation and us. We curled up in a corner with blankets and sofa foam and stayed there until 5pm the next day.

What beautiful abandon.

I was turning 30 and it occurred to me that I should think about changing my lifestyle. I don't like birthdays but not because I'm scared of ageing. In fact, I look forward to growing into someone who's a bit more grounded. I dislike birthdays because they force you to introspect.

My mum rang me up as I was coming down from my weekend of debauchery. She told me that a girl from primary school had gotten engaged and that I ought to congratulate her.

> *"She's marrying a doctor. You wanted to be a doctor when you were little. Do you remember?"*

I remember knowing just what to say to make adults happy, I thought.

What she doesn't know is that me and this girl used to finger each other at sleepovers when we were 11 years old. I thought it didn't count because she was a girl. And sometimes I worry that it was always me who instigated it.

I thought back to that suburban world. I remember believing in it. Things like marriage, my career trajectory, the property ladder. I thought about the house I grew up in and how heavy it was behind closed doors. I thought about the community, or the lack of it. Nuclear bubbles judging each other by the car they drove, and the street they lived on. Ruled by paranoia that someone or something might take those things away. I went to art school, not med school, and that's where I started to unlearn things. Engrained right wing principles like:

"Unemployed people just don't want jobs."

What a horrid thing for a little girl to think.

"I'LL SHOW 'EM JIST WHO VOTED OUT"

Chapter 27 – Red Flags

It was 12 hours until the restaurants, bars and hotels were due to reopen. Ordinarily, I'd meet my dates at the bar, or in hotel rooms, but during the pandemic this wasn't possible. I had instead adopted this reckless habit of visiting sugar daddys' apartments.

My date with Ricky was my last flirtation with 'stranger-danger' before the restrictions were lifted. The first thing I saw when I walked into his penthouse was a two-meter wide Union Jack flapping over the balcony.

"What's the flag about?" I said.

I was trying to sound jovial but the delivery was dry.

"Well them over there (he pointed to an office block across the way), ~~*they put out an EU flag, didn't they? I'm a*~~ *Brexiteer me-self. I wanted to let them know just who voted 'out' if you know what I mean. They've taken theirs indoors now. Ha ha."*

"I guess you won!" I said with a smile, trying to bite my tongue, as he popped open a bottle of pink champagne.

Despite an aversion to Europe and no connection to Italy, Ricky owned an Italian restaurant in Fitzrovia. He handed me a voucher for a free lunch and a bottle of house wine.

"There's no such thing as a free lunch," I jested and he winked at me.

He was your classic wide boy: portly and reeking of Old Spice. His shirt was unbuttoned and he wore a gold chain and had gold fillings. The restaurant was Ricky's HQ but he had fingers in a lot of pies.

"Show us the puppies then," Ricky said and I got my tits out.

We had a quick suck and fumble but when we went to have sex, he wasn't hard anymore.

"I'm sorry, I was drunk before you got here. One too many over at the restaurant getting ready for re-opening. Not to worry, I'll give you a little sweetener anyway. Money's the one thing I've got too much of. Go ask Gollum for your little envelope, atta girl."

124

I waved hello and goodbye to a life-sized statue of Gollum from *Lord of the Rings*, then curtseyed down politely to get the envelope of cash from under his armpit.[31]

"Thanks."

"Don't forget to come say hi," he said pointing to the voucher I'd left on the sofa.

[04/07/2020, 04:12:51]

Lotte: *Fancy a mediocre carbonara in town sometime? It's on me.*

Go on, it'd be fun.

[31] I'd got better at setting my ppm rates by this point and I knew what should be in the envelope. I checked the amount in the loo before leaving.

Chapter 28 – Sugar Crush

I got stood up outside a restaurant. Stood up on the second date by a sugar daddy who I'd erroneously pinned as rather taken with me. He described himself as:

"A Good Old, Straight-Up, Right Wing Gentleman."

I'd never heard anyone identify Right Wing as a positive before.

The reality that he wasn't coming sank in amongst the Covent Garden hubbub as I turned from pleasure object to cruel joke within 20 minutes. It was a fancy restaurant and the maître d' looked sorry for me.

It hurt more to be wrong than to be stood up.

Mr Andrews: Ah, sorry. The clue was in Right Wing.

BOSM BAKE OFF

Chapter 29 – A Sweet Tooth

You'd think that all this time spent revelling in debauchery with people who are often cheating on their partners would render me cynical. Far from it. The sleazier my sex life gets the more romantic I become. Sex for me is not necessarily an intimate act. But other things, like sleeping next to or cooking for a person, feel precious to me.

People mistakenly think that exchanging money for sex would mean I had a pragmatic outlook on relationships, but I'm riled at any suggestion that I'd be dating someone for money. I put love and art on a pedestal and tend to fall for Marxist poet-types.

I can separate sex from emotion with ease but am a sucker for an unrequited love affair every now and then. These pervasive infatuations are superficial and require that the person on the

receiving end of my adoration be entirely disinterested in me. In lockdown, I was struck by one such crush.

It was all BOY's fault actually. He'd met a hot couple on a hook-up app and arranged to meet up. He'd invited me along in what I suppose you'd dub a swinger's date. We went to the pub, went back to their place and that's the last thing I remember.

LOTTE: *Did I have sex with anyone last night?*

BOY: *Seriously? You don't remember that very large dildo?*

BOY relayed the evening to me like a swinging scene from a 70s porno. I was told I had sex with the wife in their living room whilst he went for a piss-drenched shower-fuck with the husband.

BOY: *Just as he was reaching for a condom you rolled over and fell asleep.*

So, you don't recall me imploring you to get up off the floor, I suppose.

You don't remember I had to dress you like you were a rag doll.

LOTTE: *Enough! Enough! It's too embarrassing (giggling) – I'm still drunk.*

I sobered up with an espresso and went to lie down on the patio outside. I can't have been a very good lay. Apparently, I curled up naked on their floor next to the log stack. They let me sleep it off like a taxidermy house pet whilst the rest of them fucked into the small hours.

What could I remember? I remember her silhouette from behind as I brought a round of drinks to the table. I liked how her thighs were spreading on the picnic bench.

LOTTE: *I've fucked her and I don't even remember it. What a waste!*

BOY: *She's magnificent. They both are.*

LOTTE: *Thank you for getting me home in one piece. Sorry I let the side down.*

I texted her a picture of my cunt and a watery-eyed apology emoji. She was nice about my misdemeanour. Sternly mocking me. Sending pictures of her masturbating in her black standalone rolltop bathtub. The ones with lion feet.

Oh my god! I think I'm in love with her, I thought. *Or… maybe I'm just in love with her bathtub.*

I knew I had to meet her again, to be sure. She was all I could think about.

In my enthusiasm, I probably came on too strong. I don't really care if I did. I love telling people how I feel about them.

One weekend she texted me:

> *Hey Gorgeous, I'm getting radio silence from the hot couple I'd lined up for this evening. Now I'm all revved up with nowhere to go.*
>
> *Drink?*

We went to a bar and sat at a dark corner table with a candle. Then she invited me back to her place. There was a pan of meatballs on the stove and the dog was sleeping on the hearth; the hearth where I had previously passed out. It was me who initiated the leap from talk to touching by kneeling next to her on the sofa and kissing my way up the inside of her leg.

I am not sure how to end my sapphic indulgences so after two hours of posturing and toys, I excused myself.
Dwelling on her attributes in my own bed that night, I thought about her and finally managed to cum.
She had an opinion on absolutely everything from mushroom foraging to video games. She switched topics like cutting through butter and gave me this sense of urgency to experience life at the same pace.

This is the kind of person who'll introduce you to things you didn't know existed, I thought, and I wasn't wrong.

She took me to a Russian sauna. They do this thing called Parenie which involves getting beaten with birch and eucalyptus twigs. A masked man came into the room. He laid me on a butcher's block and whipped the air with his bouquets. It's not the branches that take you aback, it's the heat from the sauna. As he swirled the hot air down over my chest, forcing me to gasp. Then he rhythmically beat me, from my head to my ankles, making swishing noises like a car wash.

When her turn came, I spied on her through the tinted glass doors to see her back glistening with sweat. Then we poured ice cold buckets of water over each. It was a strangely intimate experience,

Three hours later, she drove me to the tube station. Child seat in the back, me in the front. I hopped out like her teenage daughter promising to text when I got home, thinking that I'd like to have kissed her goodnight.

"See you soon," I said through the car window.

"We'll see," she said staring straight ahead at the traffic lights.

Even though the sugar sites would render me past my sell-by-date at 28 years old, I found myself craving this woman who was a decade older than me. I desired her for her proficiency and boundless energy. The difference between her and I being accomplishment. ***She was an accomplished lady.***

It's not just me; **BOY** fancied her too. We compared notes on the bits of her body that we enjoyed most and the things we'd like to do to them.

"I'd love a night alone with her," he said.

Just before another lockdown the four of us went to a hotel. A novelty-themed hotel with gaudy Pop art props. Up in the room, we fucked under the light of a *God Save the Queen* neon sign. It was a tussle of limbs without much completion. The kind of orgy with no attention span. A little bit you, a little bit me, a finger in every hole.

She has so much command over her body's ability to enjoy itself, I thought.

There was a strong sense of harmony between her and her husband. They were truly enjoyable to watch because they knew the ropes of each other yet had voracity.

She was the focal point. And the main attraction wanted two cocks inside her so **BOY** and the husband folded around her thighs to supply the demand. I watched in awe as they double penetrated her.

Before she put her clothes back on, I took advantage of those last moments. I moved across the bed, straddled my legs around her from behind, and kissed her neck. It was like I was trying to absorb her post-coital womanliness.

She pushed me away kindly and pulled her knickers up.

BOY: *Did you feel left out?*

(We were in the cab on our way home and I was nibbling chocolate coins under my mask, complimentary at the hotel.)

LOTTE: *No, not left out. Superfluous maybe.*

In our group chat, I noticed how she bristled differently when **BOY** or her husband complimented her photos than when I did. And if the topic of conversation fell on my photos instead of hers, she'd frost over and wait for the conversation to move on. It became impolite to acknowledge me at all in the conversation thread.

The three of them began meeting up without me, which was probably for the best.

Naturally, she made it her challenge to keep up with The Great British Bake Off. So, during this time I received many pictures of her baking milk buns with her tits out or wobbling cheesecakes provocatively.

I do so like to be goaded, so what better than a homosexual crush on a heterosexual powerhouse who sends you pictures of cakes you cannot eat.

DREILOCHSTUTE

Chapter 30 – TEX

90% of my sugar dates didn't want to see me again. But occasionally there's someone like TEX who wants to keep me around, and it's always for the wrong reasons.

Why the name? Well, he **did** come from Texas.

TEX arrived drunk, having sealed a business deal that very afternoon.

I arrived at the bar just after him, a dusky little joint around Belsize Park. He was wearing jeans and a pink shirt and chatting with the bartender.

> *"I bet you know how to make a cocktail or two,"* he said pointing his fingers like smoking guns. *"Recommend something, I'm a tequila guy. And one for the lady too."*

"I'll have something short and strong please," I said.

The self-mythology, the bravado, the directness, he was every inch the *Daddy*.

Everyone has a creation story. Dating is one of the only times this comes into focus because you are forced to explain yourself afresh. His story was bombastic. It explained everything you needed to know about him in one breath.

TEX was a Mexican kid from the wrong side of the tracks, raised by a single mother. At twelve, he showed extraordinary academic prowess and gained a scholarship to a predominantly white boarding school. Then an Ivy League university. Then Wallstreet. Then Beyond.

His life was a paradox for he was both an *American-Dream-Boy* and ideological orphan.

The waiter bought over two drinks with a smug glint. TEX had a leather infused margarita and mine was some kind of thixotropic coral coloured atrocity, with a disproportionate garnish to liquid ratio. It tasted so syrupy that it made my tonsils twitch.

"I made you a drink that matches your colourful dress," the bartender said.

I started grilling TEX. I wanted to know everything: How he got on as the only Hispanic boy in his class at boarding school? Did he know his father? Did he believe in God? He seemed happy to talk. He filled me in on his university days, making way for a discussion about the economy.

*"The problem with the British economy is the welfare
system,"* he said.

"How so?" I said.

*"Benefits make people apathetic. Of course, you're not
gonna stand on your own two feet if you're being spoon
fed by the state. Don't get me wrong, I'm not saying that
you should adopt the American system, just that allowing
people to kick back with new sneakers in front of their
widescreen TV is not the answer."*

I wanted to say I was still leaning on benefits this side of the
pandemic but I felt too ashamed. I sucked the last of the fruity
drink through a paper straw. I wished I had the balls to say to
him:

*I'm on benefits and it's not really enough to live comfortably
which is why I'm looking for cash gifts from rich men like you
in return for sex.*

I didn't fit his depiction of a scrounger. My accent is too posh.

*How do I say this without coming across cunty? I am and have
always been a freeloader, but as far as I'm concerned it doesn't
come free.*

*I learnt early on that wealth is relative to your environment. And
for people who don't live hand to mouth it is impossible to
imagine, even for someone like TEX who started off that way. I
was raised amongst oligarch brats and trust fund children. My
peers had bodyguards, heated swimming pools and titles. From
a young age I got very good at piggy-backing off other people's*

affluence. It was excellent training for my latter life with Candy Girl.

I'd never experienced so little return on my attempts at employment as I did at this point in my life. I might have been in a luxury bar with a £15 drink but that very morning my card had bounced trying to buy washing powder from Poundland. Nevertheless, I don't feel uncomfortable in luxurious settings and that's the gift of privilege that I've been bestowed. This contradiction is exactly how sugar dating sites think it ought to be – sit in that bougie bar until a Daddy sweeps me off my feet and to hell with Poundland because I won't need washing powder anymore.

I don't expect anyone to praise me for my life choices but I do pay. I pay in a complete lack of security.

When I worry about what people think of me, TEX's views are what I fear most.

I went to the bathroom feeling like I might lampoon my tampon at the wall. But having invested my time thus far I was keen to progress the date so I could get some money out of him. When I returned, he was settling the bill. He flashed me a grin and invited me back to his place for Puerto Rican chicken.

> *"You've nothing to worry about coming home with me, I assure you. My mother taught me how to treat a lady. Those southern values run strong in me."*

> *"Good manners never go out of fashion,"* I said.

His mews house was a bit bare, but it had potential. He handed me a plate and I tucked into my chicken supper on the sofa. The way it fell off the bone was something else.

Then we commenced the money chat. I'm really bad at this kind of discussion in person. When I'd set a figure, he pulled his wallet out of his pocket. He had a lot more cash on him than I'd asked for which left me thinking I'd set my price too low. He counted the money out and put it under a glass photo frame. Then I unbuttoned his fly and took my lips right down to it.

///

The next morning, he texted:

> *I'm still feeling last night. I think we were exceptionally compatible, sexually speaking. Problem is, now I want more (devil face emoji).*

I got the sense that I could shock TEX. He was someone who'd never really walked outside of the straight and narrow. It coaxed this cruel streak in me that wanted to punish him for his trinity of beliefs:

Hard Work
The Good Book
& Family Values

After that he invited me for dinner at his place. A romantic candlelit dinner for two. It was pissing down rain. When he swung open the door, he had oven mitts over his shoulder and beckoned me upstairs. It seemed he wanted to avoid catching the neighbours' attention.

It smelt like Christmas. Red wine and rich meats, a warm welcome from the weather.

"Hmm, what is that you've got in there?" I said, pointing to the oven and kissing him on the cheek.

"Boeuf Bourguignon. Make yourself comfortable," he said and passed me a glass of red.

I kicked off my heels and my wet coat. The news was on, some shaky footage with a caption underneath:

Right wing protestors break into migrant housing.

In the video three guys were knocking on doors asking bewildered, bedraggled families if they were illegal immigrants. Ambushing confused-looking people who didn't speak English.

"What a fucking awful thing to do!" I said.

"I know, it's crazy!" he said, and for a moment I was impressed by his compassion. But then he continued, *"How can migrants come here and expect to be put up right bang in middle of the city?"*

"Where else would they go?"

"I mean anywhere, they could be housed somewhere remote. People work hard to get a roof over their head and that's gotta mean something to the people who've earnt it."

"Somewhere remote, like a Siberian Gulag?"

"Alexa, play Nina Simone," he said and began swaying to the jazz.

The meal tasted as good as it smelt. After dinner he started complaining that he hadn't made me orgasm yet. Normally, I'd go to the trouble of faking it but with TEX I slightly enjoyed not bothering. After realising he felt spurred on by the challenge, I retracted that conviction. I lay back over a large pouffe whilst he tried to make me cum with his mouth. He looked up at me and said:

"I'm not going to stop till you get there."

I pretended to orgasm so he'd stop. But as I bucked in pseudo-rapture, I whacked my head on the edge of a thick glass coffee table and became disorientated.

"Hold on a second," I said, pinching the top of my nose, my eyes smarting.

"You're fine, honey. You're fine," he said and pulled my mouth down to his cock. *"Watching you cum was amazing."*

As I was leaving, he said:

"I hope you're not seeing other… umm, actually I don't want to know what you get up to." Then he saw me out the door with the same hurried shuffle he'd hustled me in with.

///

Over the next week my swollen forehead turned into a black eye.

A couple of dates down the line, I began to wonder:

- How many shades of pink shirts he had.
- What was in the cupboard at the back of the kitchen that I wasn't allowed to go in.
- Did his grown-up children like him very much?

I'd begun to refer to him socially as *'TEX, what pays my rent'*. I was his sugar baby. I guess.

> *"What I really want is for you to stay the night and then I can cook you brunch in the morning. I bet you'd be really cuddly to sleep next to,"* he said.

My initial thought was no. Then yes, but it'll cost you. I set my price high and he bargained me down. Which put me in a strange position because although the amount was more than I had earnt that whole month, the money wasn't great by the hour. [32]

I felt guilty and greedy for contradictory reasons. Guilty for doing it and guilty for not doing it. Who was I to turn down the money? Particularly the possibility of making money whilst I was asleep. So, I agreed.

Sleep is such an intimate act. Letting go enough to be unconscious in front of someone requires trust. I wasn't

[32] With escorting you leave when 'the clocks up'. With sugar dating you have to make an excuse like "I've got an early start tomorrow." Staying over concerned me because the light at the end of the tunnel was diffuse.

especially worried about what might happen but didn't trust TEX to not take advantage of me for his every whim over 10 or 12 hours, or however long he deemed our slumber party might last.

I packed dental supplies: electric toothbrush, floss and mouthwash. I didn't fancy not being able to gargle the cum out of my throat. He was watching the telly when I arrived and almost seemed not to expect me. A nice normal night in.

It occurred to me how beautifully natural it is to spend a night in with someone you know intimately. You have no cause to look at the clock and don't feel any pressure to entertain. It's hard to chill out with a person until you've broken through that barrier. The whole time I was thinking that I didn't know this man. I had no notion of how TEX liked to spend his evenings.

After we had fucked a couple of times, we lay on the carpet with a blanket over us looking at the ceiling. If it had been a French film, we would have been smoking.

> *"Why don't you go on a normal dating site?"* I said. *"I mean, why don't you just look for a regular girlfriend?"*

He looked melancholy, like it hadn't occurred to him before.

> *"Because I don't fit in. With the city boys, I'm the only Mexican guy in the room and with the community I come from, I'm a cultural traitor. Who would want that?"*

He told me a story about his Mexican girlfriend at college who'd told him he was selling out and playing *The White Man's Game*. His admission made me feel sad at how much loneliness there

is in the world and angry that people aren't allowed to be who they are without committing to a clan. I tried to say something encouraging:

> *"I'm sure people are clamouring to bunk up with you. You're more interesting than just a straight up city boy, and besides you're a mean chef!"*

We retired to his bedroom. He switched on the television, as though by habit. Like it was a hotel room that we'd just checked into. There was something transient about his set up.

The mirrored cabinets opposite the bed reflected everything at close range, including the TV. I've had plenty of sex in front of big mirrors, but this was a stark image, a whole wall of reflection in a tiny room.

Sitting under his arm whilst he flicked over the porn channels felt like an extramarital affair at a motel. I took advantage of his taste in porn to goad him about what a slut I'd been that past month. Around 1am, we started to prepare for actual bedtime. Right before we went to sleep, I said:

> *"You're not one of those high-functioning people who only need four hours sleep and get up at 5am, are you? If so, please let me sleep!"*

I'd meant it as a joke, but it had been a lingering concern.

I took the side of the bed near the mirrored cabinet and looked at myself lying next to this lonely stranger. It was tragic to think of all the lonesome people lying in beds next to other people who also felt alone. But I'm not lonely. I'm surrounded by

143

people. People who text to see how I am and take the time to tell me off if I'm being a twat.

Even though I found the pillow inadequate I managed to drift off. I had dreams that I was running away from HMRC, a recurring nightmare that many freelancers have whenever the end of the tax year comes around.

Next thing I knew his fingers brushed my perineum.

Oh god, what?! I thought, half asleep.

Before I was properly awake, he'd planted his cock inside me. He didn't say a word but rolled on top of me and started thrusting away. Pinning me down with my face in the pillow. I thought about retorting but pretending to be asleep seemed favourable. Co-operation would have spurred him on.

Really? It doesn't bother you that I'm not responding at all? I thought, watching from the corner of my eye in the mirror as his hand crushed my thigh.

I closed my eyes.

This is the point in real life where you should say something like *"let me fucking sleep you creep"* or *"get the fuck off me"* but I didn't say anything. I felt confused about what was expected of me. If I'd paid for someone to sleep over, I'd want my fair share of action too. But we'd already had sex three times and would no doubt do it again in the morning, so how many times would suffice to come good on my side of the bargain?

If I'd found him attractive this rude awakening may have been romantic. But I didn't, so it felt revolting.

After he had finished, which may I add was without a condom, I was going to go back to sleep to avoid conversation about it but then I thought about the repercussions. If I didn't wee, I'd probably get a UTI and that wasn't the kind of souvenir I wanted to take home with me. I couldn't decide which was worse but chose the responsible thing and went to the bathroom.

He burst out laughing when I stood up.

"Look at the time!" he said. *"That's funny!"*

It was 5:15am.

"Why is it funny?" I said.

"Cos you know what you were saying about high-functioning businessmen getting up early."

"I'm going back to bed."

We slept for another three hours. I woke up thinking that I wanted to get out of there. But first BRUNCH, that bit would be tasty at least.

As I stirred into the world, I looked at myself in the mirror and recalled with seismic disgust TEX on top of me. I was overcome with the conflicted urge to masturbate. I touched myself reimagining his weight on top of me. How he'd treated me like his personal sex slave, a semi-conscious cum receptacle. I felt genuinely violated and that was the biggest turn on of all.

145

He woke up as I was cumming.

"Oh, baby! I would have helped you out with that," he said.

"You already did," I said. He looked bewildered and I enjoyed it.

TEX laid on the filthiest brunch you've ever seen: meat after meat after caffeine after meat. A sausage fest with piggy bits on the side. Our breakfast conversation was strange. I sat with my knees up at my chest, wearing a shirt and nothing else.

"Do you know how much the average American household spends on Christmas presents?" he said. *"$800! Isn't that surprising? How do you want your eggs, scrambled or fried?"*

"It is quite a lot, I suppose. Sunny side up please."

"A lot! It's nothing, it's peanuts! Imagine your bill? Or my bill for Xmas presents by comparison? Another cup?"

"No, I'm buzzing!"

How much money did he think I spent on Christmas presents? Why on earth did he think we were in the same boat?

I thought about my mum and how much she spent on presents.

"My mum's a basset hound for a bargain. Last year she stockpiled 20 pence rolls of wrapping paper, enough to last her entire lifetime."

"I like that you come from a strong family base. It's the sign of a well-rounded person. I'd like to meet your mum."

"Oh, I don't think so! She'd chase you out the door with a frying pan!"

"I'm Mexican. I'm used to having to win people over. I'd enjoy the challenge of making her come round to my way of thinking. Why wouldn't she like me? I'm a good guy and I'm patient too. Solid. Dependable."

"Ok, well introduce me to your family first and we'll see what impression I make for starters, then maybe you can meet mine."

"Well, that's not the same. You know, with my kids and everything."

"Really now! It's not, is it? They're grown-ups, aren't they?"

He went to cuddle me after the meal, but I'd already showered and brushed my teeth and I didn't want to feel dirty again. I gathered the plates and he watched from the sofa whilst I loaded the dishwasher.

"You can chill out here today if you want," he said.

"I need to get going."

"You didn't take your money yet," he said and pointed to the jug on the table.

"I didn't want to assume it was mine; it could've been for the next girl."

On the journey home I felt void of thought. I missed my stop by almost ten stations and ended up around St Pauls. So I alighted the train and walked down the embankment. The wind off the Thames felt fresh and the skyline was hazy. London was ghostly, almost no traffic. You could hear seagulls but you couldn't see them.

Chapter 31 – Crotchless

I logged into Candy Girl today and saw Uncle Al, TEX and Ricky all online at the same time. I don't know why I've got such an aversion to signing up to Adult_World[33] when all these men turn out to be such cunts.

I wonder whether everyone is forced to confront their disposability like this.

TEX doesn't pay my rent anymore. In fact, in a bizarre twist of fate, for the second time in my life, I have been dumped with a small package of commiseration underwear. In place of a Dear John letter are these here crotchless panties.

One has to laugh.

[33] The largest searchable UK escorts register.

Chapter 32

[16/07/2021, 19:33:33]

Lotte: *Does it get any fucking easier? I feel like I'm trying. But everyone tries, right? Am I going to look back on my years of sex, drugs and alcoholism as Elysian or is that only if I pull myself out of it?*

Mr Andrews: *It gets easier in some ways... and much much harder in others.*

Mr Andrews: *Quelle surprise.*

Mr Andrews: *But yes, the days you're enjoying are indeed fields of paradise, so fill your fucking boots, Charlotte.*

Mr Andrews: *I yearn for those days.*

HoT GIRL SUMMER

Chapter 33 – Donna Summer

On another grey day, I had a date with another grey man. He worked in media (again) and was wearing a Breton shirt.

I bet Mr Andrews has the same top, I thought.

We were eating French cuisine in Spitalfields at lunchtime. His pug, and sole companion for countryside walks, had cancer and was on its last legs. He was sad about the dog.

Seemingly, a replacement puppy is what this man was looking for.

"Woof in French is ouah, did you know that?" I said. *"French dogs have a different accent, I suppose. I mean they must! Surely?"*

"I can tell you're an animal person. I like that about you," he said.

"I'm scared of dogs actually. I'm quite scared of men too, as it goes. I'm also scared of the countryside. We've not started out on the right foot, hey?"

"Do you want to see a photo?"

It's ugly to be jaded, isn't it? Cynicism ages people, all those scathing expressions and eyerolls are bad for the soul. But I couldn't help it. I'd been on so many dates and they all mistook me for being a sweet girl. It's like I was screaming into the abyss, but they had me on mute. At least Mr Andrews saw what I was really like. He listens to people.

My date asked me why I was on Candy Girl. Same old question. I gave him the same old answer. By this stage, I didn't really know what the real answer was.

"Something to do whilst the clubs are closed?" I said.

I asked him in return.

"I work a lot so I can't always, ummm, be there. But I don't want to book a professional, you know. I want something more real than that. The tenderness but not, ummm, the commitment."

"Yeah, I get it," I said. *"The twilight zone suits you."*

The twilight zone was suiting me less and less. Why didn't they ever want to book an escort? Why did sugar daddies object to sex workers when they are clearly happy with the concept of transactional sex? I show tenderness and empathy as an escort much more so than as a sugar baby because I respect honesty and I like the autonomy of my own business. I also like the sex bit of the work and would prefer that to be the focus. As a sex worker I am open-hearted; as a sugar baby I feel like a pampered pet.

This guy, I couldn't tell you his name. There have been so many. He didn't want *ppm* which is what I'd asked for; he preferred an allowance set-up. I thought about it for a minute, a regular income that is. It scared me because I'd be beholden to him like he was my boss. If it's sex I'm selling, I never want to feel owned. [34]

He mentioned a nurse whom he'd dated. He sent her £1200 a month and they saw each other like a regular boyfriend/girlfriend thing. On average they dated three times a month for ten months and went away on weekends together too. They parted on civil terms.

> *"She gets her Chanel handbag and I get to turn off my engine for a bit, if you know what I mean. Are you working by the way? I wouldn't want this to be your only income. I mean, you know."*

[34] Similarly, what was stopping him from going on a regular dating site? There are plenty of people who aren't looking for commitment. Not just men.

Because then I'd be reliant on you? And you don't want that commitment. Well, I wouldn't want to rely on one person like that either. Allow it to be its own business and you won't feel that way. On top of that, you're possessive and want exclusivity along with that allowance. And at some level you also find the idea of transactional sex repugnant because you think you're a catch. So, there's a contradiction happening here, isn't there?

I wanted to say this but instead I changed the topic.

> *"I like the music in here, disco. Strange for a lunchtime choice."*

They were playing Sylvester and I was bopping around in my seat.

Fuck! I can't wait for the clubs to reopen, I thought. *When we can travel again, I'll fly straight to Berlin.*

I didn't used to leave the house until I'd played this song for the road. I thought it was a good luck charm. Every time I hear it, I'm there. Four to the floor, in a sweaty, nasty, heaving basement. I can't see my friends through the dry ice but I know they're in here somewhere.

> *"You know what, I'll be honest. It's just so annoying for a guy. I mean if you don't, er, DO something about it you're just thinking about it all of the time! That white noise gets real loud sometimes. So, sue me, I'm doing something about it,"* he said.

Not with a sex worker though.

He thought he was being honest, but he wasn't.

"Do you wanna funk?" I said. **clap clap**

"Sorry?"

"The music. I love disco. I mean like high NRG 120bpm+ like Disco-but-daggy. Gay-as-Fuck, emmène-moi à la discothèque. Give it a cow bell. Take me to Venus. Disco."

That same club was the first time I got fucked on the side of the dance floor by a stranger. When I was reunited with my friends later on, they said:

"We couldn't find you but we knew you'd be alright, wherever you were, because Donna Summer was playing."

An extended mix of 'I Feel Love' melted over me and I felt such a glorious animal with five or six men watching me get fucked against the dank walls of the club. Stroking their cocks whilst this virile young man, who didn't speak any English, pounded into me. I was gently coming up on half a pill and the ceiling felt like it was closing in. The corner of the club was like a cave, gritty and littered with condoms.

"Ah, my partying days are over," my sugar date said. *"You don't want to see me dance. I thought you said something else there for a second."*

"I did."

"Ha. I thought I was gonna need to get you drunker first before we got that far."

"I don't hear white noise."

"No, women don't. That's why they're such reasonable beings."

"I don't hear white noise. I hear Donna Summer."

Chapter 34 – Critic's Choice

Somewhere between on/off lockdown, TEX, turning thirty, unemployment and the sugar sites, I became a bit of a loose cannon, and I gave zero fucks about it.

I was shagging a lot of people, not just from Candy Girl, all over the place really. There was this one boy Ryan, for example, who I met at a pretty rough-around-the-edges orgy.

[18/04/2021, 09:21:40]

Lotte: *This orgy happens: Once a month, in a dungeon, under a plumbing wholesaler, on an industrial estate, near the South Circular. Now, if you can't find it from those detailed instructions, you're no boy scout my dear.*

I kept bumping into Ryan and one day I got a text from him saying:

"Hey."

Two hours later he was at my front door asking:

"You on the pill, yeah?"

He had this plan that he was going to sodomise me, cum on my face, then fuck off to his mum's house for dinner. He undertook this plan and before half an hour had gone by, I was watching him walk out the door again.

With no work, no nightclubs, and no visible exit, getting roughed up seemed like an act of conviction amongst the tedium. I got a powerful kick out of it. Once I got going, I picked up speed.

Mr Andrews: *I can't keep up anymore.*

Lotte: *Try harder.*

This escalated into a Booze'n'Bang fuelled supernova that imploded on itself. I landed amongst a generous pile of pillows, unable to get out of bed except to the kettle and back for cup-a-soups. **BOY** wasn't speaking to me, I wasn't answering my friends' texts and my head was pounding.

What pushed this frenzy to its apex was a man called Hugh. My evening with him was the single most degrading sugar date I've ever had.

Hugh had just broken up with his wife. They met on Candy Girl when she was 21 and he was 44 and split up because she had wanted babies. The trouble with children being that they duly grow into adults.

> *"Yes, and she'd aged badly over the course of our marriage, I'll tell you that much,"* he said.

It was a rainy Sunday and Hugh had nearly cancelled on me for the second time. I knew from the offset there was no way he'd be attracted to me, but I had to go and meet him because somehow, we were a mirror of one another.

He was a food critic by trade but had also published a memoir about his sex life. He was the type of man who preaches the lost art of masculinity to anyone who'll listen. Which is, unfortunately, a large congregation. And, he was into DDlg[35]

> "*I like to write about my dates too but from the receiving end of such dynamics,*" I said.

Of course, my view is not as rosy as his. I take more risks as the 'little girl' to his 'Daddy Dom':

> "*You've got the money, the power, the validation and don't expose yourself to quite the same risk of being chopped up into a suitcase,*" I said.

He pointed out that he **does** have something to lose.

> "*I'm vaguely known, and you're – well, not.*"

And the nubile baby-girls…

> "*It's not easy for me to live out in the open either. I console myself by saying this is how God made me. I can't help it.*"

We met at the pub next to his house, to ensure minimal effort on his part. Disappointment was all over his face when I arrived. I could see it from the slight raise in his left eyebrow as I greeted him.

> "*It's ok if you just want to sit and cry into your wine glass,*" I said.

[35] DDlg – Daddy Dom-Little Girl – is an age-play BDSM dynamic.

"Men should only cry in war and women should only swear in bed," he said.

The waiter came and I suggested we share a bottle, in need of something to take the edge off.

"A bottle? Jesus, we're only staying for one and then we can drink for cheaper at mine. If it gets to that."

"You're clearly used to lightweights," I retorted.

But the waiter managed to upsell him a bottle anyway and he wouldn't stop banging on about how mugged he felt.

"It's alright for you, you're not footing the bill."

He saw my lip curl and made a slight about how girls like me found financial banter crude because we came from money. It's all relative I suppose. He may not have fancied me, but he was perceptive and didn't treat me like fragile baby doll which I appreciated. I asked him about the Michelin starred restaurants and if they were all they were cracked up to be. He confessed that being fawned over by chefs quaking in their boots was "excellent fun".

*"What do **you** do to get by then?"* he said with a glint in his eye. I mashed together an answer.

"Umm, furlough right now. But I doubt I have a job to go back to at the end of it all because I don't exactly thrive in the workplace. Furlough and other bits and pieces."

"Go on…" he replied, gesticulating in a circular motion.

160

"Sometimes those bits and pieces include escorting, sometimes sugar dating. But to be honest I'm not very good at handling the money part of the latter."

"Ah ha, knew it!" he said. *"If you're bad at your job and you're a terrible whore, then what can you do?"*

WHAT – CAN – YOU – DO, LOTTE?

His words cut close to the bone.

"If only I knew," I said smiling.

The humiliation was both damning and made my nipples hard.

"And how do you pay your sugar dates?" I said.

"I don't. Not in a million years."

Since he didn't regard Candy Girl as a roster and didn't like to splash his cash either, I wondered what his dates got out of him. Dinner, I suppose.

We finished the bottle and he said, *"Back to mine."* It was a statement not a question. I asked if he was sure, knowing it would be a car crash.

"You'd have to be a Nazi midget on meth for me not to want to spank you, and even then I'd be tempted."

It wasn't until we got through his front door that he got the chance to see my costume: an oversized schoolgirl in bobby

socks, a pleated skirt and a white button up shirt. I'd intended my *'get up'* to be disarming.

"What chunky thighs you have, my dear!" he said.

He asked me to do a twirl, then instructed me to take the socks off. Then he took a couple of swigs of champagne and said:

"Lotte, can I penetrate you now before we go any further? I'd just like to get that out of the way."

We went into his bedroom where he started to fuck me, but stopped soon after.

"This isn't working, I'm sorry."

We tried spanking instead. He curled me over his lap on the sofa and smacked my arse for a bit. But we stopped that too because it felt awkward. I had a big bruise on my buttock the next day.

We went back to drinking and swapping vastly personal, depraved stories. He seemed to think my sexual behaviour was quite extreme.[36] I was surprised he felt that way as his tales seemed more pendulous. From prison to God. From drugs to fame.

"Yes, but I'm unusual," he said. By inference I wondered what he thought I was: *a common-or-garden slut?*

[36] He was the seventh person I'd dallied with in as many days.

He told me about his ex's numerous abortions, the harrowing repetition of unfulfilled procreation. He launched into a lugubrious sermon about life, death and parenthood.

"Why did she keep getting pregnant?" I asked.

"I have super sperm."

"No really, why?"

"It's not my fault she kept whipping the condom off right when I was about to cum."

*"So, you **do** use condoms, gotcha! Johns who don't like Johnnies is all I ever seem to write about. It's making my journals rather repetitive."*

"I'm not a John."

"Well, no. You'd need to be paying me to fulfil that brief."

"Is that what you want, to be a writer?"

"I only want to write about real life. It seems stranger than anything I can make up."

"All writers write about their life."

I told him about my stint working for Rubenesque.

"They billed me as Lady Lotte, Molliges Schulmädchen. I like to write about things like that. The banality of them."

He clapped his hands together.

*"Yes, that's it! That's what you are! Say that phrase
again."*

"Molliges Schulmädchen."

In his glee, he spun me round and fucked me again for a bit, like
he was giving me one for the road. He pushed his cock into me
with my torso pressed between the stove and the extractor fan.
It was a bit more successful than our previous attempt. I gripped
a tea towel for support and was mindful not to knock the electric
hob on.

"Ah, it's no use," he said, giving my arse a big slap to put
a full-stop on it.

"You're a big girl, Lotte," he said, making a gesture of my
shape with his hands. *"But you're lovely company."*

He called me a cab. I went to the bathroom and felt my eyes
prick tears. Simultaneously feeling emotionally exhausted and
turned on. Hugh had been the anticlimactic punctuation mark in
my sex marathon. I stared at my reflection and said to myself:

"This is what you came for. Enjoy it, girly."

I swilled a little water in my mouth from the tap. I patted my
tear ducts with a tissue and composed my face before leaving
the bathroom.

The next day I woke up feeling like someone had carved out my insides. I excavated my phone from the pile of bedding. There was no word from **BOY**.

He'd stormed out of my house at some point that week saying that he couldn't stand watching me throw myself at these cunts anymore.

I missed him. The kind of 'missing' I didn't have the balls to look at head-on.

No text from **BOY**, but there was a text from Hugh.

> *What is the German word for chubby schoolgirl again? You also left your umbrella. You are the best fun!*
>
> *Thanks for all the kisses!*

Chapter 35 – Sugar Crash

BOY texted me.

BOY: *They're so entitled, they don't even think they have to pay their whores anymore; what does that make you?*

LOTTE: *I enjoy it and that itself is a subversive act.*

BOY: *I fail to see how polishing their self-serving dominion is success.*

LOTTE: *But I write it down. Isn't that a small act of justice?*

BOY: *No one reads your writing. They read Hugh's.*

The only true subversion would be to transcend them, and I fail to see how.

Following this episode, I took a break from sugar-dating. My mind and body were exhausted.

LONDON SWANSCAPE

Chapter 36 – Marshland

Around Christmastime, my flatmate, Heather, got sick with 'the virus' so Valentina and I walked to the testing centre to get ourselves checked too. We stopped for a drink on the way back thinking it would be the last time we'd be allowed out for a while. The act felt European, but the view was desolate. Three tower blocks overlooking a miniature marshland with too many swans per square foot. And then, whilst Valentina and I were sitting there, drinking cola through a straw, I saw you walking up the track with your kids. I only glimpsed you out of the corner of my eye, but a flush came over me and I couldn't turn my eyes from the ground. I pointed you out to Valentina and she looked over. Later that day, you texted me.

[16/12/2021, 17:21:40]

Mr Andrews: *Why didn't you say hello!? Nice to see you. x*

Lotte: *Oh! Y'know too busy swooning 'n all. Why aren't your kids in school?*

Mr Andrews: *School was closed due to half the staff going down with Covid.*

Lotte: *We were on the way back from the PCR testing centre.*

Well anyway... you could've come and said hi too. I was there already so the ball was rather in your court. I will never intervene if you have kids with you. I'm not that kind of a nuisance.

Mr Andrews: *I admire and respect your discretion, but I was looking over at you and you wouldn't look at me.*

As much as you try to compartmentalise things, when something from one world permeates into another it seems abrupt. A tear in the fabric. I was titillated to see you IRL but it's not something I could handle on the regular.

[17/12/2021, 10:11:57]

Lotte: *It was Covid! — Hallelujah! It's a Corona-Christmas — just as well I didn't blow you a kiss, hey.*

Mr Andrews: *Is it Omicron? Slightly aching to get it so it's over with.*

You need to pace yourself. You have DAYS left.

You know, it's been about a year since I last sugared myself out. I bleached my hair blonde and lost a bit of weight and once the vaccine kicked in my job-life started going better too. You could say I cleaned my act up a bit. **Ta dah!** The drinking's worse than ever, mind you.

You never put it into so many words but I guess you must have thought I got hotter too because you started fucking me occasionally. For free, but still. And you don't bother with the restaurant preamble anymore, just the sex. The first time we tried to fuck overwhelmed me. You know every little thing about me, penetrating me physically seemed a step too far.

Ages ago, you asked if I had any expectations of my dates. I thought it was an insightful question, and no, I don't really. Expectations lead to disappointment. I've certainly got no expectations of you, but I very much enjoy our utilitarian screws.

//

Mr Andrews: *I worked out I want to get Omicron by 27 December. When does that mean I should surreptitiously come round and share fluids with you to ensure proper contagion?*

Mr Andrews: *Unless you're a Delta variant bitch, in which case you're no use to me.*

Lotte: *I'm not entirely sold.*

So, we're neighbours nowadays! I don't know how I feel about inviting someone from *that* world into my space. What an intimate experience, a far cry from the faceless hotel rooms.

I am your local whorehouse.

[18/12/2021, 13:40:22]

Lotte: *Ok, well of course I'm up for it.*

I cleaned my house, changed my sheets, shaved, painted my toenails, washed my hair, and sat down next to my telephone awaiting your reply.

You didn't text.

And I found myself thinking:

Are you giving me everything I ever wanted? Is this it?!

I texted you a few more times.

I went full spectrum from:
Apprehensive
To game
To desperate
To restraining every part of myself not to beg you to come over.

You didn't bloody text back, you arsehole!

To fatigued
To accepting

And now I've tired myself out imagining which glorious animals you pay-to-play with and how much better they are than me. I've wanked and dreamt and looked at myself in the mirror and let the humiliation permeate every pore of my skin. And

thrashed around in my duvet in erotic self-loathing and given over to the theatrical potential of harsh rejection in the most naked of ways.

I think I'll cool it for a couple of days.

FUCK – it's better than sex
It is SEX

For me anyway.

You know, I think you envy my freedom and that's the only reason you talk to me ever.

Merry Christmas, darling. We're still friends, right?

xxx

Lotte

Chapter 37 – Tory Tits

Work was thin, as it often is in January. I opened Candy Girl again for what turned out to be one last date. There were hurricane warnings and my heel broke on the way to meet my date. The man and I had coffee then he tried to get me to give him sexual favours in the back of his car.

"If I don't try you, how will I know we're compatible?" he said.

He wasn't violent but he did coerce me into his vehicle. He trampled through my noes interpreting my lack of consent as a lusty challenge. I ended up running away from his car.

Fuck you.

Fuck you.
Fuck you.

When I got home, I popped a benzo. Then I logged into my Candy Girl account and deleted my profile forever. I looked at the ceiling and contemplated my rage. How can someone so passive feel so violent?

I recalled a dinner party I'd been to pre-pandemic. The guests included my mum, my oldest friend, her brother (the boy I lost my virginity to), their parents and a bunch of people I didn't know.

One of the boys, a next-door neighbour apparently, was infatuated with my friend.

People falling for my best friend is a theme from our school days. She has an alluring smile that doesn't quite give everything away, maybe that's why I love her too. Our teens were littered with naughty nights out that would always go the same way. I'd attract a small group of men by being loud in the hope they'd buy us some drinks. A handsome man would latch on to my friend. They'd ask me whether she was single. They'd have a less attractive friend who felt obliged to buy me a drink and then we'd sit there not talking.

Boy-next-door was quite the bon vivant, making sure everyone had their drink topped up and telling tall tales as though it were Pimms O' Clock. I took an instant disliking to him because he was a young banker and dominated 50% of the opinions in circulation. I was sat next to him which wasn't quite as close to my best friend's thighs as he'd like to have been. The table was big so the chat broke into two halves.

Boy-next-door, who I'm going to call Rupert, started telling a story about a gag he'd pulled for a friend's birthday.

> *"When I was a lad, my father wanted to make sure us boys didn't get into trouble about town. So, he'd send us down to a brothel in Mayfair on a Saturday night because he knew the girls would look after us. Nothing untoward, just sort us out with a few beers, make sure we didn't get too rowdy. Good women."*

Am I hearing this correctly? I thought.

> *"It was my dear friend's twenty first birthday and I wanted to make it count for the old boy."*

My tongue disappeared into the side of my cheek.

> *"SO, we're holding a grand dinner party over at his place. A soirée! A feast! And just when the wine begins running dry I send Badger, the birthday boy, out to the offy. When he returns, little does he know that he's got a surprise waiting for him. Unbeknownst to Badger, I've snuck in one of those girls from Mayfair and she's all trussed up in her undercrackers, dressed like a French maid!"*

I was enthralled to see where he would take this anecdote.

> *"The poor lad is so embarrassed he doesn't know where to look. But then I slap him on the back and say, 'Don't worry, old boy, I've only gone and booked you a prozzie to wash up all these dirty plates.' And then we lay back enjoying the view whilst she did the clear up. A fine end to a splendid evening!"*

I mean, it would have been quite hot, if it wasn't a joke. Everyone laughed along, snorting and guffawing like it was the funniest fucking joke they'd heard all year.

"I think that's disgusting," I said. *"I think you're disgusting."*

They all looked at me like I'd said something awful.

I had no allies on my end of the table. You could hear the cutlery. The other half of the table seemed uncommonly loud.

"Lovely ham," said a woman.

Rupert noticed her empty glass and filled it. She looked kindly at him and the conversation finally moved off.

I have a lot of time for my best friend's family. They've always tolerated me for some reason. I spent far too much of my adolescence at their house.

As I cleared the plates away, I made a back hander about having no sexy maids around to do it for us. The boy I lost my virginity to, who you could call my first love, piped up.

"All this talk of sex, I remember when you were a virgin. Ha ha."

He said it in front of the whole table. He said it in front of my mother. It makes me convulse how he still sports my hymen as some kind of badge of honour to boast about at dinner parties. How is he allowed to say that and no one bats an eyelid? But when I say something provocative, it's deemed unnecessary.

I can't call him my first boyfriend because he was too embarrassed to go out with me. For the best part of three years, he'd coax me into his room in the dead of night and beg me not to tell anyone whilst continuing his business about town as though I didn't exist. I daresay he's partially responsible for my masochistic streak.

Every now and then he sends me an apology text, probably when he wants a leg over. I have this underlying suspicion he might think we're destined to be together. I say, *"I forgave you a long time ago but it doesn't mean I want to hang out with you."* And that's a lie because I haven't forgiven him and it's been 15 years now. I tolerate him for the sake of everyone else. I remember vividly, from the age of 13, wanting to lose my virginity so no one could hold it over me as some sort of power play and here I am a 30-year-old woman experiencing just that.

"Virginity is a social construct," I snapped back.

Eyes rolled. They're surely going to stop inviting me to these things if I keep up such a stance.

"Oh! Fuck off all of you!"

Not long after that, the same family invited me to a charity gala boxing dinner. I was excited. I'd never been to a casino, let alone a boxing match. The business boys were in penguin suits signing contracts at the table over salmon en croûte. The ring card girls in high-rise thongs held up numbers in the ring. It was glamorous and a bit seedy. The sweaty, muscular men threw punches. I was shouting and banging my fists on the table.

After dinner my best friend and I spent our pin money on the tables. She became possessed by a gambling spirit and lost all of our chips. The man next to her gave her more chips so she would stay at the table. *"That's my girl!"* I sniggered waiting for her to lose them.

Later, at the bar, a loud man touched her bum and we ended up stuck in conversation with him. He made a joke about how his PA was over-qualified but he'd never tell her that or she might start angling for a promotion.

> *"She'll never see a penny more from me,"* he said with chuckle.

I was riled from the fight, and so was he, and I'm going to wager he was coked-up too.

> *"It's so unpleasant when people talk about their staff like that,"* I said.

> *"Is this some women's lib thing?"* he said.

> *"Women's lib? What century are you from? We have the vote nowadays."*

A tad juvenile, I know.

He didn't like that. He pushed me hard against the bar with both hands on my shoulders. I wanted to hit him so badly that I punched the silver padded pleather bar behind me. Someone stepped in between us before I could retaliate.

As it turned out, the man was one of the main benefactors of the charity dinner. He was a total cunt but no one took kindly to me berating him. I felt annoyed at myself the next day.

I never seem to conjure my pugnacious alter-ego when it's really needed. My last sugar date was case in point. I can think of countless times that I've gotten confused about what was happening and responded inertly.

Shortly after I started writing to Mr Andrews in 2019, I went on a sugar date that really tipped the balance for the first time. I can only describe him as a barrel scrape. We were at a hotel in Soho and the guy rang his wife in front of me and told her he was having a drink with a colleague. Then he hung up and laughed about how gullible she was.

He decided that he ought to call a 'proper' hooker to join us in the hotel room. Then he said I'd have to share my fee with her because he could only afford one girl. I decided to split before we got to the room. He settled the drinks bill and we left at the same time. Once we were in the lift, he jumped on me and pulled one of my breasts out of my bra, then pinned me against the wall. I didn't feel scared of his pouncing tactic but it was unprovoked, and we weren't alone in the lift. There was a young boy in there too, around ten or eleven years old. My date looked at the boy as if to say *'this is how you do it'*. He kept trying to pull my clothes off and backed me into the corner. The little boy looked scared.

"Don't fucking touch me!" I said in a feeble tone.

The boy ran out when the doors opened. Only when I got out of the lift did the anger hit. I walked in a straight line and didn't

stop, through Soho, through Piccadilly, through Green Park, until it had dissipated.

After this date I started to rage a lot; I was chronically turbulent. It wasn't *that* man specifically who enraged me, it was everything. There are just so many arseholes in the world.

I used to value that I was obliging, polite and come over as a bit dim. Being underestimated is a stealth weapon of sorts. Although it does lend itself to circumstances such as being accosted in lifts. Or being coerced into sexual favours in the back of cars.

If only I could harness my rage properly in real time.

Would it be better to strike back?

No, of course not.

It would be better to politely assert a firm *"would you please desist, sir"* and then escalate to violence should it be necessary.

But why should I be bloody reasonable all the time? What about sex or power is reasonable?

My stepmother calls me a *champagne socialist* but when I went to Blackpool I got called *Tory Tits*. A man in a karaoke bar said he could tell the way I voted from the bra I wore:

> *"I can tell you're not a real Northern lass because you don't have your winter bra on,"* he said looking at my nipples through my jumper.

How we did laugh about it. I'll answer to the name **Tory Tits** if you want to call me that.

I get told what I am all the time.
Failings aside, I think I can see exactly what I am.

I wish I could tame the fury into something beautiful. Learn to sing a righteous lullaby that charms the perpetrators whilst I wait for them to fall on their own swords. But for all my convictions, deep down I know that if push came to shove and something really bad happened, I wouldn't defend myself. And you can't unknow that about yourself.

Chapter 38 – Anthony and Cleopatra

I'd been swiping through dating profiles on a hook-up app. It was my attempt at a healthy re-entry into the dating scene. My life after sugar as it were. After initial titillation, the format lost its lustre. Something about the way I'd curated myself as a sex object with photos and a bio was too familiar.

It felt transactional:

You've got an itch.
I've got one too.
How can we mutually scratch one another?

After years of only using apps for pay dates, I found it hard to switch the service provider mindset off. I drove myself crazy, desperate for the feedback loop regardless of whether I liked the person. That shit's quite addictive.

I arranged a date with a couple. They were older than me and seemed on my wavelength. Midweek, somewhere in Notting Hill, I was with a man and woman who I'd met 35 minutes earlier. Feeling like an escort, but not getting paid like one. We'd arranged a date at a bar but it changed at the last minute to *Me* meeting *Them* on the tail end of their dinner date and driving back to his place.

I didn't really like Anthony from the moment he opened his mouth. Which begs the question…

Why was I there?

> *"Pulse is not a dating app. It's for hook ups,"* he said.

> *"Ah, so we're hooking up, are we?"* I said with an eyebrow raised.

Cleo was excitable but nervous. Anthony was suave.

They'd both left their marriages at the beginning of the pandemic and had met between lockdowns where they began making up for lost time. Good for them. They both had kids, shi-shi careers and a nice kitchen. I could see myself as the titillating froth that accessorised their wholesome existence.

> *"Have you done much of this before, threesomes I mean?"* she said.

"Group sex. Gang bangs. Orgies. I'm well sullied in all my holes," I said. It came out unintentionally deadpan.

"Wow, so you're the voice of experience here. You'll have to teach us a thing or two," Anthony said. *"What's the wildest tale you can regale us with?"*

"Umm…" I hesitated but couldn't resist the opportunity to play raconteur.

"Come on, hit me with a good one."

"Hit me up with a slug of scotch and I'll tell you," I said and he filled my glass. *"This one's about an A***** engineer from my time as a Berlin call girl.*

"Figures."

*"Ok, so you know A*****? Yeah, them."*

"They flew this guy out to a conference and he wanted to have some fun whilst he was away earning the big bucks. WASPy geek, mid-fifties.

He'd smuggled some MDMA into the country in a hand-crafted box and asked me to guess where he'd hidden it. So, the date started by me rifling through his luggage and the drawers in his hotel room. I was throwing shit all over the place but I couldn't find the stash.

I gave in and he showed me a secret compartment inside a tin of travel mints. It was like one of those magic tricks kids buy from the store. He had the Molly all ready to go in

bombs, twisted up in cigarette papers. I only pretended to take it and flushed mine down the loo.

Then he wanted to play restraints. He'd bought some rope at a local hardware shop. It took maybe an hour to tie me down. He asked my weight and height so he could figure out proportional forces, etc. He was into physics and off his tits. He lashed my forearms to my upper arms like BBQ chicken wings.

Once I was bound to the bed, he reached into his bag of tricks. I thought he was looking for condoms. But to my surprise he pulled out a self-inking rubber stamp.

It was some swag they'd been gifted at the conference.

He set about dobbing me all over with the logo. I looked down and what did it say?

*Property of A*****.*

For real! I was washing it off my legs for days.

Once he was done playing with his new stationery, I called time. As I was dressing, he said, 'Y'know, you're a strange, strange girl.'

And I was like: Back at you, mate."

After story time, we started kissing. Compliments were ricocheting from every direction:

"You're so gorgeous, hun."

"Look at those tits."
"I love watching you, baby."

I'm not used to this during sex. Adoration from near strangers does nothing for me.

I excused myself before it escalated into sex, thinking that I'd been responsible about the whole thing.

Anthony and Cleo interpreted my early exit as a sign that I was taking things slowly. I wasn't planning to return. But I went back and fucked them the following night.

On our second date, we went to a nice restaurant. Anthony said he was celebrating his successes from the week. A large business had got behind his first round of funding.

"It's all a game – you've got to think like Machiavelli," he said. *"Make them believe they want in."*

He asked Cleo about her week. She'd won new business. Big names. Big contracts. It had been a winning week all round.

We took a cab back to Anthony's. His daughter rung him crying about her GCSE exam whilst we were in the taxi. I felt like I was watching a film of someone else's life. He gave her a motivational pep-talk:

"Look, honey, you're from a long line of winners. Trust ya Dad. None of this will matter one day. We make our own luck."

Once he was off the phone, he talked about how nonsensical exams were. I agreed.

> *"My mum says you don't fatten a pig by weighing it,"* I said.

> *"She's not wrong there,"* he said.

Anthony was like a sugar daddy but he didn't know it. He was self-made, not at the hand of any institution, mind you. He made a jibe about my schooling and how easy I'd had it.

Am I the self-destroyed woman to his self-made man!?

I went to the offy and bought some wine as a thank you for dinner. Because I'm well bought up, as has been noted.

What they really wanted was a sugar baby, I thought. *Someone to spoil with their self-made riches whilst they get off on how freethinking they are. I'm done with all that.*

Whilst Cleo and I were making out, Anthony got his phone and filmed me kissing her tits. I made a mental note that he hadn't asked permission.

We fucked with Anthony dipping in and out of us gleefully.

As the sex wound down into cuddling, Cleo said, *"Sleep here, sleep here!"* But three's a crowd when it comes to duvets. I don't like sleeping next to strangers. Even more so since my sleepover with TEX.

I looked at my phone. It was glowing with messages from Uncle Al.

Uncle Al?! A blast from the past. But… tempting, I thought.

I looked over at the smooching couple beckoning me to lie next to them. I looked at the empty bottle of gin next to the bed and thought:

No.

I guess one's life choices are self-perpetuating. I could join the cuddle puddle. Or, I could go get used by a lecherous old banker. Despite all the compliments and adorative 'love making', Anthony and Cleo actually made me feel shittier about myself because they saw me as a sex-ccessory, nothing more. But Uncle Al, he saw me as a disgraceful wanton slut.

So I split. I took a midnight cab to Uncle Al's glass house on the Thames. I took a bump of MDMA on the way and texted him a synopsis of my evening thus far to warm him up.

> *"I like it that you've come pre-fucked,"* he said upon my arrival. *"You look like a mess."*

We fucked for hours. When I say fucked, it wasn't just penetration. It was pure degradation. I was on my knees. He slapped me. Pulled my hair. Laughed as he told me what type of girl I was. He pissed in a corner of his shower and asked me to lap it up like a dog. And I loved it. He and I were on a level. Just for the evening, nothing more.

> *"Breather?"* Uncle Al said.

I got off my knees and we shared a line of coke on his balcony. I felt calm.

> *"Do you ever find it a bit arbitrary? You living in this fancy building, making loads of money, pissing it on girls. Like success, I mean, it feels totally random to me.*
>
> *Do you think I'm dumb because I don't do what you do?"*

> *"No, I don't think that. The guy with the highest recorded IQ score is working at a tiki bar mixing piña coladas, I'm told."*

> *"And where do I sit in that analogy?"*

He shrugged. *"Everyone likes a piña colada. How much do I owe you?"*

> *"Ummm... £300?"*

> *"Let's call it six. You undersell yourself. You know you can make some actual money doing this if you do it right."*

> *"For some of the shit I just did, I should think so!"*

> *"And what do you know about that?"*

> *"Thank you. You're an asshole but the good sort. The sort that knows what they are when they look in the mirror and just deals with it."*

I thought about it. What Uncle Al had said.

I knew sugar wasn't working, but escorting that had never been so bad. Granted, the guys weren't that different but the parameters were. I didn't leave my escort dates feeling exploited. But I felt like Anthony and Cleo were exploiting me and there wasn't even money changing hands.

A couple of days later I texted them enquiring about those videos he'd taken.

He fobbed me off.

I asked again.

They didn't share the videos. Maybe they were worried they'd have something to lose if I shared them.

It started to grate on me because they thought of themselves as *the good guys*.

I asked again and then got arsey.

> *"I don't mean to paint you as naïve but I turned a blind eye to you filming. If you take a video, I want a copy of it,"* I typed.

They got defensive and said they hadn't shared the videos because they didn't like how they looked.

> *"That's not the point,"* I replied.

Then they got needy.

"I love what we have, it's so hot! Not just the sex but the conversation," Cleo said.

They cooed their respects and admirations in my direction.

"Yeah sorry, I'm not feeling this anymore," I said.

I'm happy to blow hot air up someone's arse for a fee.

What Uncle Al said was not all wrong. I perused the profiles on Adult_World. It was appealing. Better money than Berlin, less competition. The money was more than I'd ever got as a sugar baby and these girls set their likes and dislikes right there on the page.

- Hotel meets only – no problem.
- I could say ffm threesomes were my specialty and make it a niche.
- I could be done in a couple of hours instead of tipsily missing the last tube home.

It's honest, unlike these scum-daddies I've been cavorting with.[37]

Proper escorting again.
Paid by the hour.
No fees.
No cut for the agency.
No ambiguity.

[37] Apart from you Mr Andrews! We're both wretched but you're not a *scum bag*.

Chapter 39 – Courtesy Call

My re-entry into escorting was reaping far greater rewards than Candy Girl ever had. But you and I, on the other hand, still had some unfinished business.

[07/02/2022, 20:25:02]

Lotte: *Come over babe! I want you.*

Mr Andrews: *Alright then, tomorrow lunchtime?*

My flatmate woke up just before you were to arrive and threw a strop that I was inviting random married men over in the morning. She stormed out. It wasn't morning; it was 1 o'clock.

I began to think it had been a bad idea.

"Why is it always some moral dilemma with you?" you said.

It's so personal! Surely you can see that.

You drove and weren't drinking. You had, what, like an hour and a half on the metre? I opened the bottle of wine you brought and necked the first half of it fast.

You coming into my world is something I've fantasised about for a long time now. The ultimate disclosure of space and situation. The way I keep my shoes in a row under my bed, how we work around one another in this tiny space.

I don't think the sex was very good; we've had better. You finished yourself off in a hurry, talking about what you'd like to do to this girl that you used to have a crush on. Were you thinking about the girl, or the parking meter?

Curtis Mayfield came on and you liked it. I wanted to tell you that I liked Curtis Mayfield too, but I preferred Bill Withers. I lost the ability to string a sentence together. Nothing ever comes out of my mouth in a straight line. A couple of days went by and I hadn't heard from you, so I texted:

[12/02/2022, 23:44:50]

Lotte: *Can't believe you didn't say thanks for hosting — sigh.*

Mr Andrews: *I iz all class, innit.*

Oh! and thank you so much for hosting, it was such a 'unique' experience.

JOKE!!!!

I mean, come on, you know I get to the messages once every few days via children's sick, tantrums and meltdowns so spare me your straw man... I'm going to withhold the bisexual fantasies next time as punishment.

Also a joke. C'mon.

On a more serious note, I had a total blast and amazing time and came like a comet. So thank you from the bottom of my pencil case.

I thought you sounded deranged. I suppose you have your own problems and all that. Anyway, I was coming up on E in a club toilet when I messaged you and didn't care what you had to say.

Writing to you is nothing but a confessional kink.
So, take it with a pinch of salt, darling.[38]

Why don't you do me a solid and fall in love with me for a change?
It's probably the only thing that's gonna deter me from pursuing you.

You do a good Bill Withers on karaoke, apparently. Ok, so the way I see it, it's like *Waiting for Godot*. You and I are trapped

[38] A boy once told me about a sex-worker with a similar compulsion: "She had a Tourettic need to tell me about all of her sexual encounters." He saw it as vindictive. But it's not for me, and I doubt it is for her. I wonder if the isolation one feels as a sex worker, or deviant, living a fractured existence requires a sounding board. With several phones, three aliases and twelve email addresses – it feels good to come clean all in one place.

in one of those padded booths in a karaoke bar and we're suspended in this purgatory with an inexhaustible supply of cocaine and saké to while away the endless hours. That's where we're going to be until each of us goes mad. Strung up on our own neurosis'.

[12/02/2022, 02:25:11]

Lotte: *Darling, don't get cocky.*

*I just want to give you **everything***
*knowing that it would mean **nothing** to you.*

Chapter 40 – A Rake's Progress

I was in my bedroom with **BOY** divulging a detour I'd taken to your house. Thing is, I don't know that it was your house. It was kind of a hunch. Maybe it'd just been a fantasy of mine. Something to do to amuse myself for an afternoon. I didn't mean anything by it, just getting my kicks. Short of a karaoke bar in purgatory, this was the second-best divertissement I could think of.

BOY: *So, you're a stalker now!*

LOTTE: *What's that? Some sort of vitamin deficiency? God no! I'm definitely an alcoholic.*

BOY: *It's not mutually exclusive.*

LOTTE: *I was following my feet. And my feet went to the pub.*

BOY: *But which came first, the desire to go to his house or arranging to meet your friend at his local pub?*

LOTTE: *I don't know that it was his house for certain. Neither do I know that it was his local, but it surely should be. I triangulated for decent watering holes within a mile radius and that was the only viable option.*

All I did was extrapolate public information towards a public house. That's not a crime.

Did you never feel that titillation when you were a kid walking past your crush's house? The adrenaline prickles. Rehearsing over and over what you would say if you bumped into them.

BOY: *So, you've always been a stalker then?*

LOTTE: *You're a photographer for Christ's sake. You live through a camera! You never watched the girls next door playing in the garden? Never lingered to watch your teacher pack up her things? Never looked through the viewfinder just a bit too long, catching someone unawares?*

I know you did!

My plans fell through and I was unaccountable for a few hours. I quite like that feeling. It seemed like the only thing I really wanted to do. I arranged to meet my friend at a pub nearby and reckoned I'd take the long way round so I could go via your house. Then I got nervous so I went straight to the pub. I started sweating when I was about seven minutes away. Your home

isn't really on the way to anything. It would have been hard to spin my presence as an accident.

When it comes to sadomasochism, it's always whips and chains that get the prestige. No one wants to acknowledge the psychological stuff because it's murky. But power play is all around us whether we like it or not. Manipulation and exploitation haunt school playgrounds, are the refuge of middle management and thoroughly define politics. Watch footage of parliament and tell me I'm wrong.

Of course, as a young sub-slut I read *Story of O*. The physical rigamarole left me cold but there's this part of the book where O's master, René, gifts her as a sex slave to another master so that she can learn to serve someone she doesn't love. That sinister act of objectification stuck with me for weeks.

BOY began pursuing me when he saw how far I'd take it. He was strangely impressed by my loyalty to becoming undone. I fell in love with him when I realised how creative his solutions were for soiling me. Intricate and inspired little games that neither of us would tire of. We are both committed to our untoward pleasures, even when they've been challenging. Once you accept those things about yourself, everything gets easier.

BOY: *I never disapprove of anything you do. I just don't want to visit you in prison.*

With the Tories in office, I doubt you'd be judged favourably for hanging round a married man's abode. An upstanding tax-paying man with a family. Particularly one who shirks your advances.

LOTTE: *As far as I'm concerned, I've cleared that matter up by disclosing that he is my muse. I suspect he likes the attention. And what's he going to say if anyone asks how we know each other? Nothing. He'll say nothing.*

Besides, I'm a low-maintenance nuisance.

BOY: *Hard – Bloody – Work more like.*

LOTTE: *His house reminded me so much of the one I grew up in.*

BOY: *Oh! (deadpan) Daddy!*

LOTTE: *Don't Daddy me, Mummy's boy!*

BOY: *Seeking the little life that you did become accustomed to.*

LOTTE: *Say that whilst you're suckling my nipples in the morning, grinding away like a swaddled baby doll. Mamma!*

BOY: *I'm not the one hanging around two-up two-downs in the dead of night to see if the lights are still on.*

LOTTE: *It was more of a Victorian terraced town house actually.*

Mamma.

BOY: *Daddy.*

LOTTE: *Pour me a glass of wine, Daddy?*

BOY: *How about you have a night off?*

LOTTE: *Be a good boy and get Mummy a glass of wine.*

BOY: *Ok. It's your body. All sounds like a Hallmark Christmas film. Did you breathe on the window and draw a heart? Blow kisses through the letter box?*

LOTTE: *I breathed into the cold air like it was cigarette smoke. I used to do that on frosty walks to school when I was a kid. An eight-year-old pretending she was in a French Noir.*

BOY: *Pretentious little kid.*

LOTTE: *Naaah... aspiring jilted lover! ALWAYS!*

I fucking adore you.

BOY: *You've got a funny way of showing it, by stalking other men.*

LOTTE: *Ha, yeah, 'spose.*

I adore you because you're the only one who fucking gets it. Who understands the balls it takes to own one's transgressions as a badge of honour rather than shame.

Is this it then? Have I fucked my way to the bottom? That slippery slope. Is this where it levels off? I'm ruined. I ruined myself.

Do you mind?

BOY: *It's what I like about you.*

LOTTE: *Should I tell Mr Andrews I've written a book dedicated to him?*

BOY: *I don't know. Will you be able to restrain yourself?*

LOTTE: *The thing is, it's never really been about Mr Andrews. He doesn't matter. Certainly not someone to get worked up about. But you on the other hand…*

I winked at **BOY** as he passed me my wine glass. I sipped it and savoured the familiar burn at the back of my throat.

Then **BOY** grabbed my neck and pinched it between his thumb and forefinger. At first it hurt a little and made we want to cough but then his grip settled and started to make everything feel wavy. My eyes began to prickle and my body started to go tingly. Then all I could hear was ringing and I felt a bit embarrassed because I was about to fall over. Or maybe I was about to shit myself or about to buckle or lose comprehension of right and wrong, and I just sank down to the floor. It felt soft. It felt like it would be forever soft, and it was.

Afterword

There is a double-edged media image of 'prostitutes'. On the one hand, they are represented as cold-hard-materialists and on the other, tragic victims of circumstance. In reality people are never that black and white. Largely because of this book, I got involved in 'decrim' activism with sex work organisations which has given me a support network that I never knew existed. It's cathartic to talk to people who understand the issues from the inside without judgements. I've met a full spectrum of sex workers who are far from these stereotypes. They are raconteurs, empaths, nurturers, activists, performers, and so much more.

Decriminalisation is an international movement aiming to make sex work safer by regulating it. In countries where it's been fully legalised, working conditions and legal procedures are more advanced than in the UK. Decriminalisation would aid in reporting violence to the police without fear of arrest. It would enable sex workers to work alongside another person without risking fines for 'brothel-keeping'. It would even minimise the risk of eviction if your landlord doesn't like how you earn a living. Basic things like seeking business advice, finding an accountant, a therapist, or accessing STD testing and flu jabs would also become easier.

Whenever the topic of sex work is bought to the fore, sex trafficking is always mentioned. This terrible occurrence can't ever be brushed under the carpet but it's an issue that I believe should be dealt with separately. Human trafficking exists in nail parlours around the UK, yet we don't seek to shut down the beauty industry. Likewise, the main cause of violence against

women is men, but we don't look at banning them. It's a controversial topic but one that's finally beginning to get some airtime. Regardless of the law, sex work isn't going anywhere. It's happening whether it's legal or not.

Personally, it gives me time and resources for creative projects that I wouldn't get from a regular job. I'm grateful for the space it gives me, but it can be isolating. I'm still conflicted about the long-term trajectory of sex work. I've always worried that it might be an industry where you go in at the top and gradually depreciate, a concern that directly derives from my experiences with sugar dating.

Overall, I enjoy it. I feel like I'm being honest about myself whilst doing sex work and I respect my clients if they are equally self-effacing. I think there's a place for sex work as a force for good in this way. Particularly with some of the kink-work I do.

I still worry that it's going to ruin my life if everyone finds out, but I'm glad to be a part of opening up this discussion.

I find it shockingly regressive that sugar dating is growing in a culture that seems to believe it no longer objectifies young women.[39] And it bothers me that my behaviour has upheld this patriarchal clusterfuck. I feel compelled to share my experiences because I witness just who these people are when they think no one's watching.

With sugar dating, I reached the end of my tether because I wasn't making money from it anymore. I was just spiralling into

[39] It's not just women, it's men too. But sugar dating trades youth as currency by design.

political masochism. I'm aware it's a hardcore fetish but the origins of that kink come from feeling oppressed by those same power structures. The daddies don't know that my attraction to them was subversive and I suspect they thought I fancied them for their success and power. If I put my perversions aside and imagine it was someone else's body, not my own, I've been used and exploited countless times by the very men who hold the keys to the kingdom.

All of these stories were just rotting away in Mr Andrews' inbox.

I wasn't planning to publish this book. I was going to let it sit in a box forever. But I happened upon Guts Publishing and I felt aligned with their books. They make space for conflicted topics like sex and bodies in a way I saw as refreshingly honest.

So, I sent them my messy, fractured manuscript and here we are.

Lotte Latham
9 December 2022

Acknowledgements

In 2022, I was involved in a writing course centred around amplifying sex workers' stories in their own voices run by Decrim Now an organisation at the forefront of decriminalisation in the UK. Their general message when it came to storytelling was: "nothing about us without us". It was an eye-opening experience in introducing me to other workers and fleshing out my knowledge about sex worker's rights here in the UK. Organisations like this one and collectives such as ECP (English Collection of Prostitutes) and SWARM (Sex Worker Advocacy and Resistance Movement) are essential, not just in the push for rights but also to create a community.

I feel I should thank everyone who's patiently tolerated me over the course of this process. I'd write a list, but it seems unfair to tarnish people with my muddy activities by association. I hope they know that I love them very much and owe them a drink duly.

Lastly, I know I wouldn't have felt brave enough to write as bluntly if I hadn't been exposed to work from some of the fearless artists I admire the most: Carolee Schneemann, Kathy Acker and Sophie Calle.

About the Author

Lotte Latham is a wanton experientialist who likes to see her fantasies made real. A suburban girl with a bee in her bonnet, Lotte is a fine art grad with a background in window dressing and sex work. Hopelessly inspired by the likes of Kathy Acker, Sophie Calle and Chris Kraus, her route to writing came as a way of working out the knots that come from a host of complex experimentation.

About Guts Publishing

 Established in May 2019, we are an independent publisher in London. The name came from the obvious—it takes guts to publish just about anything. We are the home to the freaks and misfits of the literary world.

We like uncomfortable topics. Our tagline: Ballsy books about life. Our thinking: the book market has enough ball-less books and we're happy to shake things up a bit.

Dear Mr Andrews (Jan 2023) is our eighth book.

The Peanut Factory (May 2022) by Deborah Price is our 70s punk squatter memoir set in South London.

Blade in the Shadow (Oct 2021) by Jillian Halket. A coming-of-age memoir about a young Scottish woman struggling with undiagnosed obsessive compulsive disorder.

Fish Town (Apr 2021) by John Gerard Fagan. A young man's bittersweet departure from Glasgow and the next seven years of his life in a remote fishing village in Japan.

Euphoric Recall (Oct 2020) by Aidan Martin. The true story of a Scottish working-class lad and his recovery from addiction and trauma.

Sending Nudes (Jan 2021) is a collection of fiction, nonfiction and poetry about the various reasons people send nudes.

Cyber Smut (Sept 2020) is a collection of fiction, nonfiction and poetry about the effects of technology on our lives, our sexuality and how we love.

Stories About Penises (Nov 2019) is a collection of fiction, nonfiction and poetry about, well, exactly what it sounds like. To quote a prominent Australian author, 'Quite possibly the best title of the year.' We think so too.

Our website: gutspublishing.com
Our email: gutspublishing@gmail.com

Thank you for reading and thank you for your support!

Made in the USA
Las Vegas, NV
12 February 2023